Praise for the dogs— and their before-and-after grooming pics— of PUPPY STYLED:

"They've got that salon-fresh feeling down." *—BuzzFeed*

"Having a bad day? This will fix that." *—Cosmopolitan*

"Eye-catching canine transformations." *—Dogster*

"Adorable dogs with kooky haircuts . . . amazing." *—Refinery29*

"Prepare yourself for cuteness overload." *—Good Housekeeping*

"PAWfect transformations for brilliant photo series." *—Daily Mail*

What happens when a dog grows their hair long and shaggy, only to get dramatically transformed by the magic of Japanese dog grooming? You end up with the cutest dogs on the planet. The result, collected here, is pure delight.

PUPPY
STYLED

PUPPY STYLED

Japanese Dog Grooming—Before & After

GRACE CHON

The Countryman Press
A division of W. W. Norton & Company
Independent Publishers Since 1923

THIS BOOK IS DEDICATED TO

Vin and Jasper

Copyright © 2018 by Grace Chon

For information about permission
to reproduce selections from this
book, write to Permissions,
The Countryman Press,
500 Fifth Avenue,
New York, NY 10110

For information about special
discounts for bulk purchases,
please contact W. W. Norton
Special Sales at specialsales@
wwnorton.com or 800-233-4830

Manufacturing by Toppan Leefung
Production manager: Devon Zahn
Cover design by Lauren Kim

Library of Congress Cataloging-
in-Publication Data

Names: Chon, Grace, author.
Title: Puppy styled : Japanese
dog grooming : before & after /
Grace Chon.
Description: New York, NY : The
Countryman Press, a division of
W.W. Norton & Company, [2018]
Identifiers: LCCN 2018022557 |
ISBN 9781682681763 (hardcover)
Subjects: LCSH: Dogs—Groom-
ing—Pictorial works. | Photogra-
phy of dogs.

Classification: LCC SF427.5 .C46
2018 | DDC 636.7/083—dc23
LC record available at https://lccn
.loc.gov/2018022557

The Countryman Press
www.countrymanpress.com

A division of
W. W. Norton & Company
500 Fifth Avenue,
New York, NY 10110
www.wwnorton.com

10 9 8 7 6 5 4 3 2

Contents

Introduction

Japan is renowned for a culture of original ideas, unique design sensibilities, and a passion for all things cute. It's no wonder then that Japan would be setting trends in the world of dog grooming, taking something so familiar to a whole new level of artistry and design.

In the West, dogs are traditionally groomed to breed standard as much as possible. These are cuts that have been designed to highlight the ideal characteristics of the respective breeds, focusing primarily on the body and legs. The goal is to showcase proper angulation in the dog, or to hide perceived structural flaws in the breed.

But what would happen if you threw all these rules out the window? Japanese dog grooming does just that, approaching haircuts from a completely different philosophy. Rather than focusing on standard breed haircuts, it has one objective: to make the dog as cute as possible! To bring out the dog's unique personality, the emphasis is placed on grooming the dog's head and face. The work is done with detail and precision, using advanced hand scissoring techniques to create fluffy shapes and lines. The result? Delightfully transformed dogs that oftentimes look like stuffed toys or anime characters come to life.

When I had the idea of photographing a before-and-after series of dog haircuts, I was immediately captivated by Japanese dog grooming. I was looking to create a photo series that combined all the themes I like to explore in my work—capturing the deep emotional worlds of dogs and their individual personalities, drawing out the unique cuteness of each character, and creating something explosively adorable. It would only make sense that I would be drawn to a style of grooming that has the same philosophy and goals.

The original photo series, called "Hairy," started with nine dogs and quickly went viral. People had an overwhelming response to seeing these dogs transformed, both physically and emotionally, by their whimsical haircuts. A team of groomers from Healthy Spot in Los Angeles made the magic possible, treating each dog's natural shaggy beauty as a blank canvas to create an adorable twist on the familiar. Through these images, we can recognize the power of transformation and the possibilities that can come from change. Sometimes, all it takes is a great haircut.

—*Grace Chon*

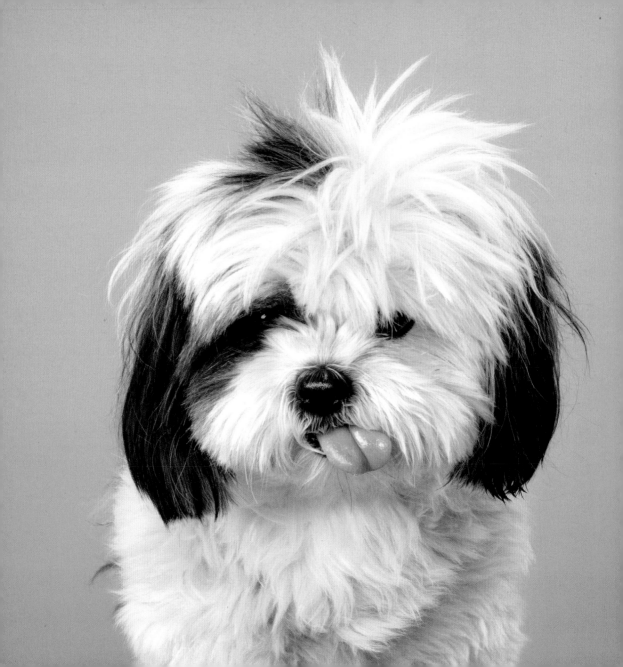

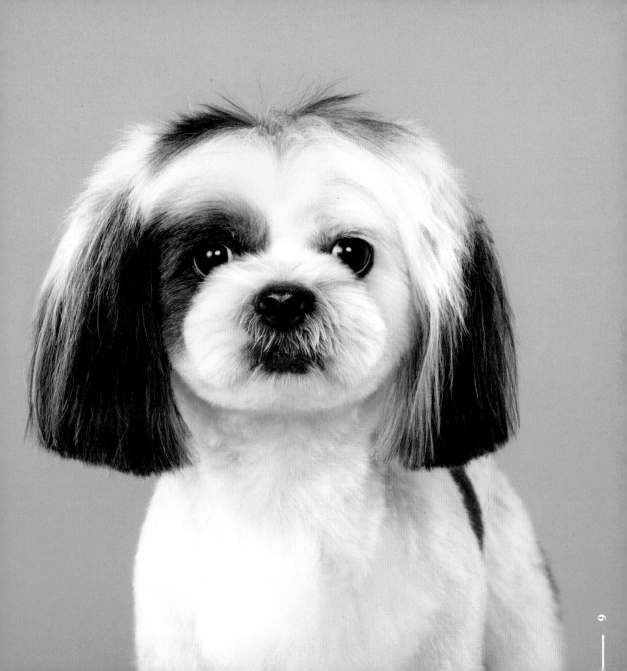

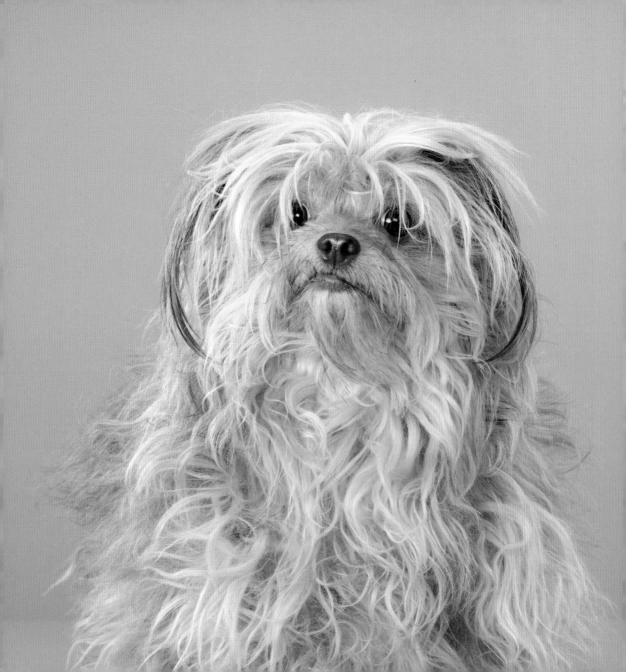

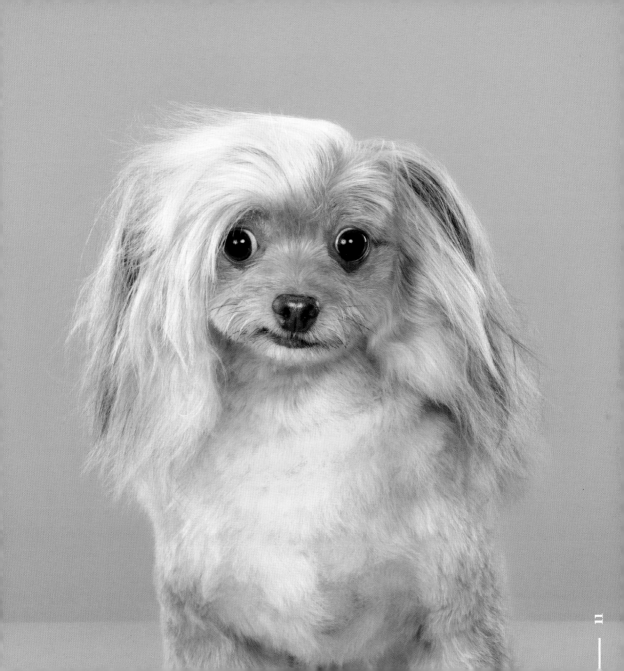

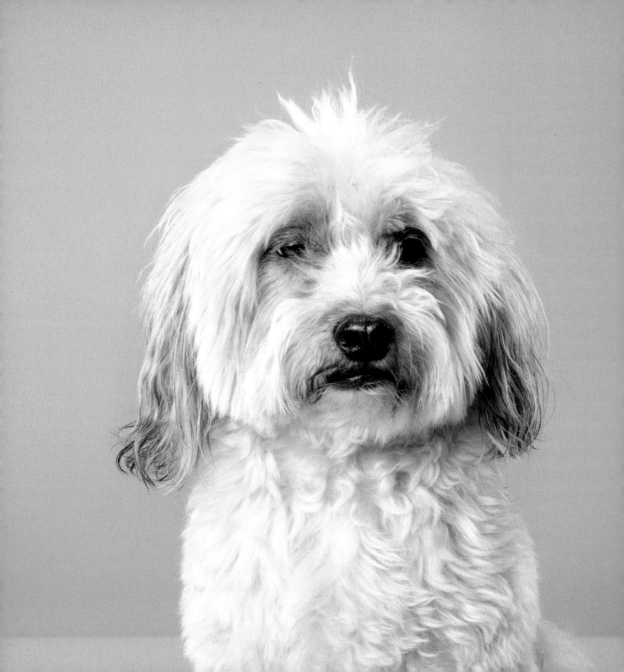

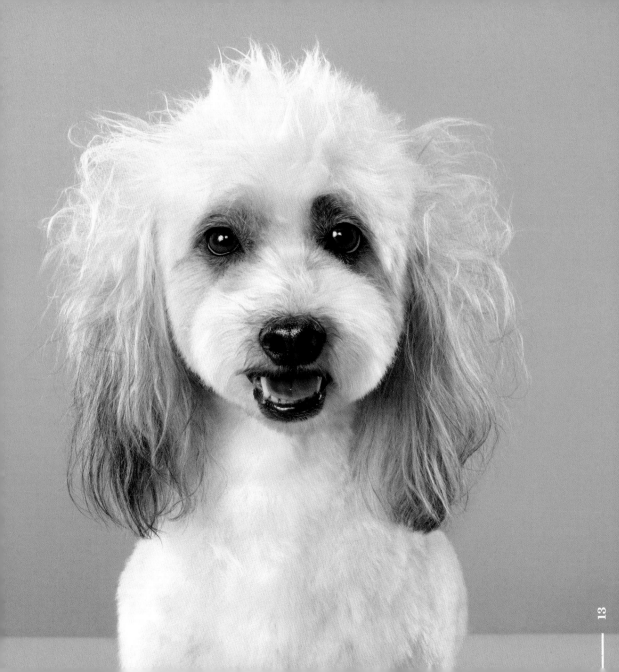

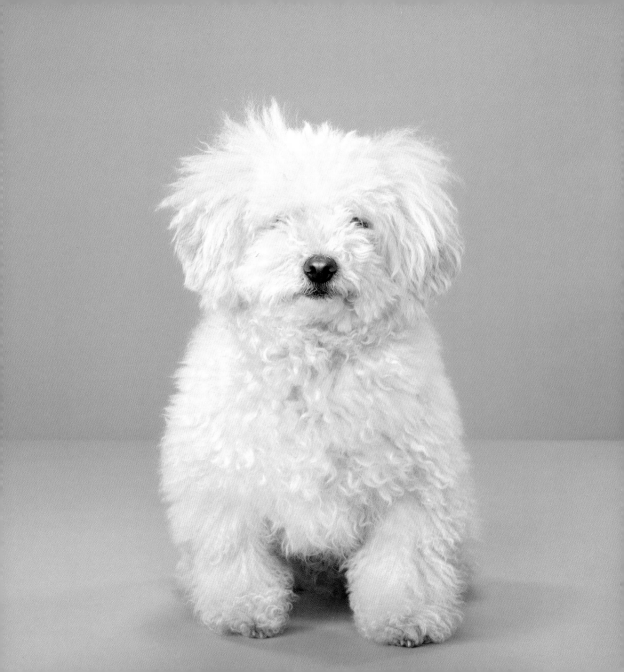

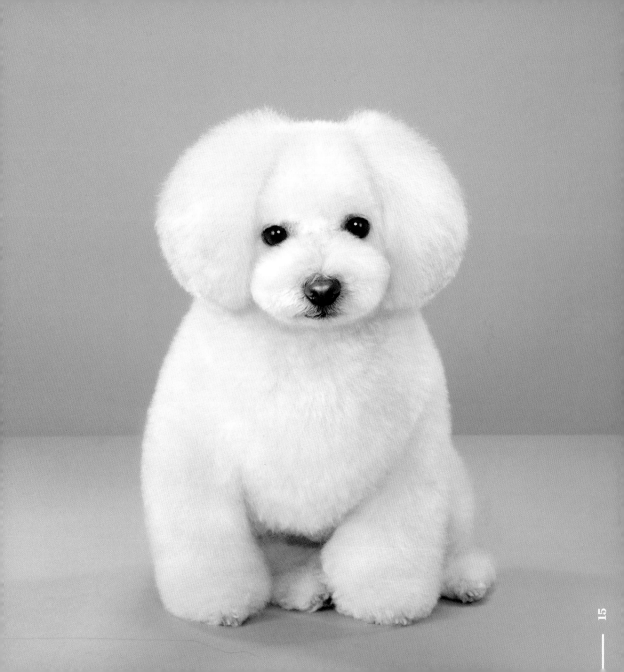

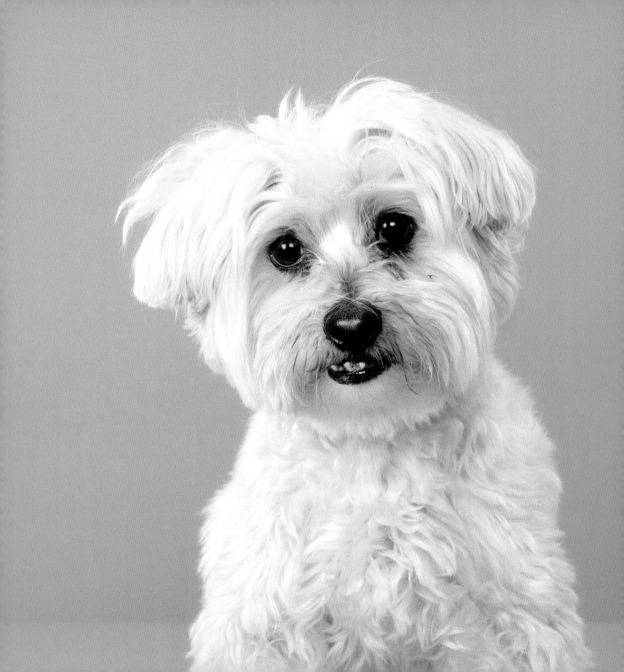

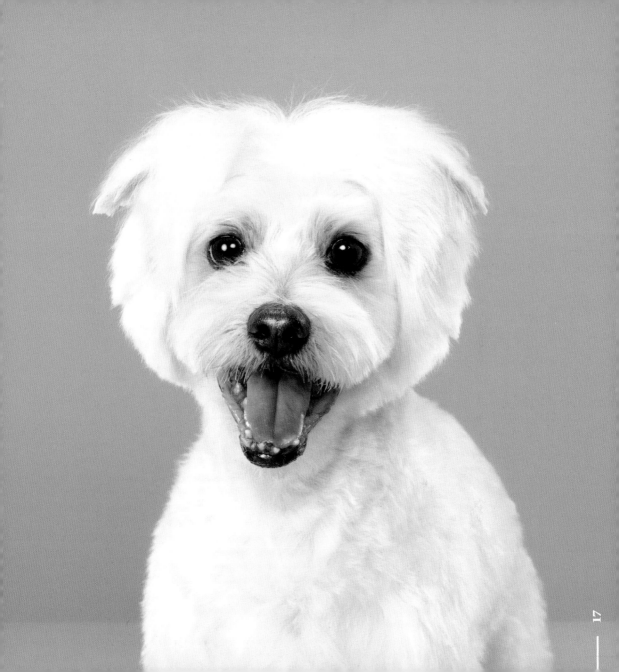

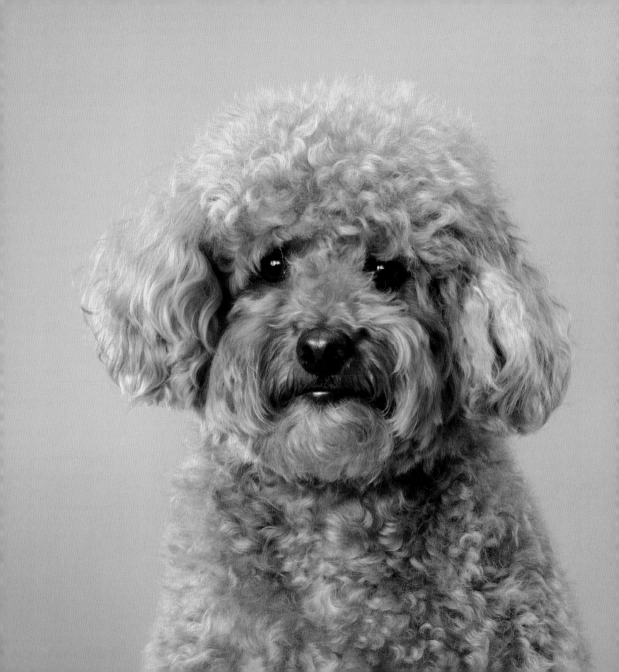

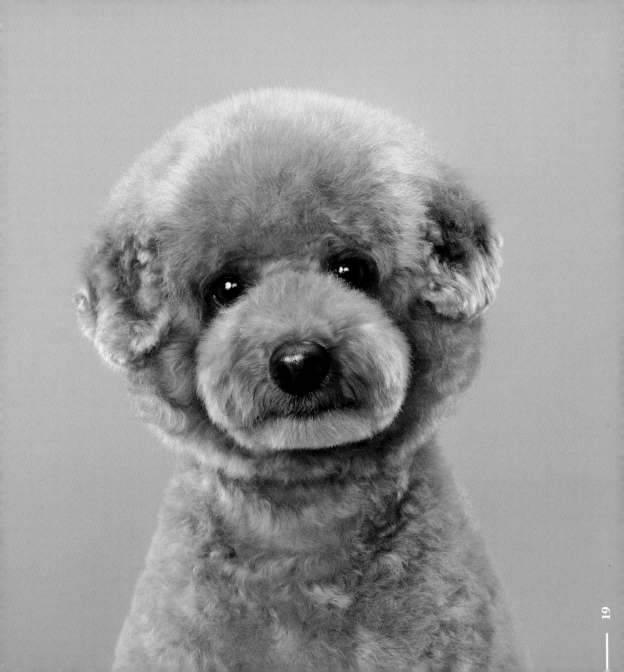

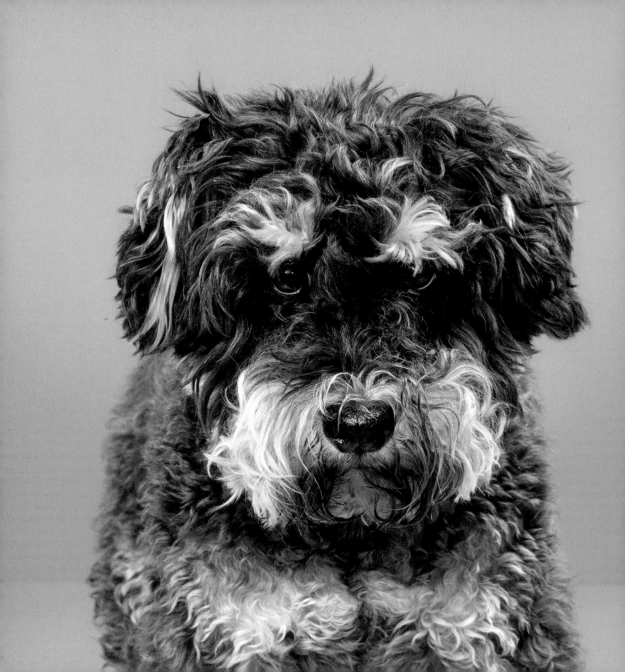

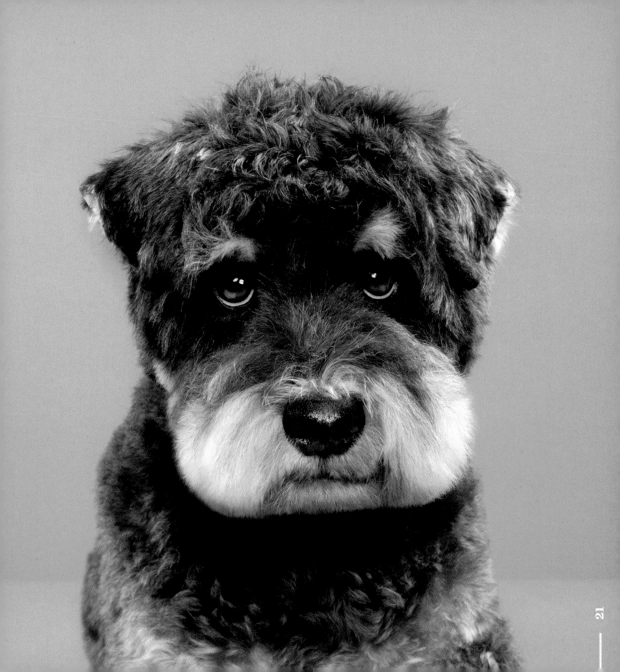

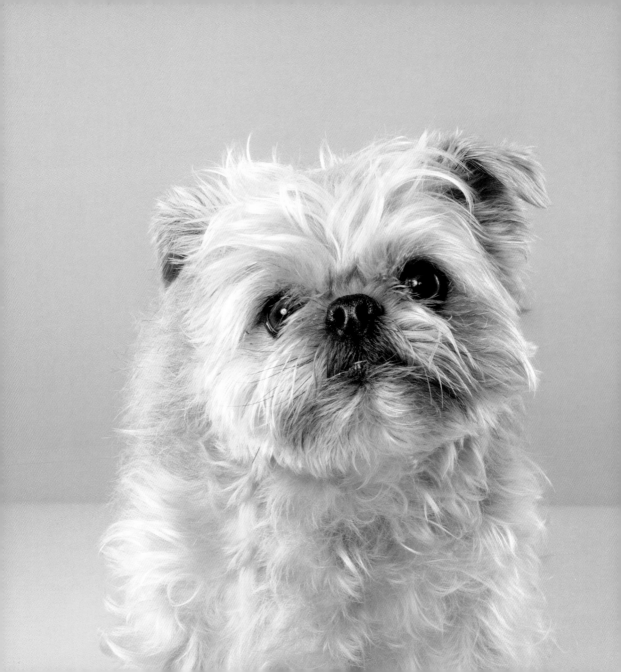

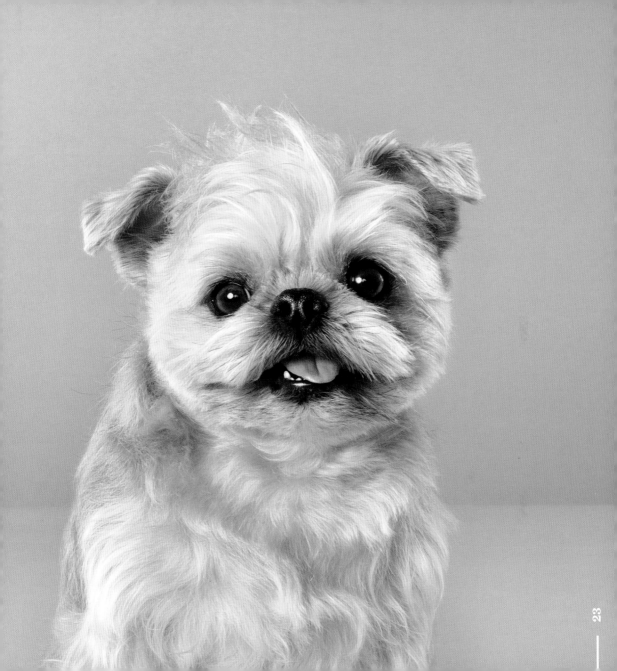

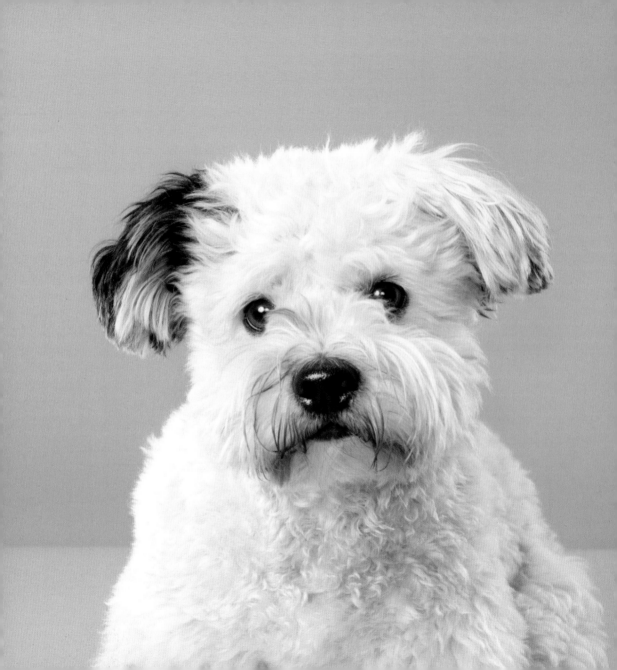

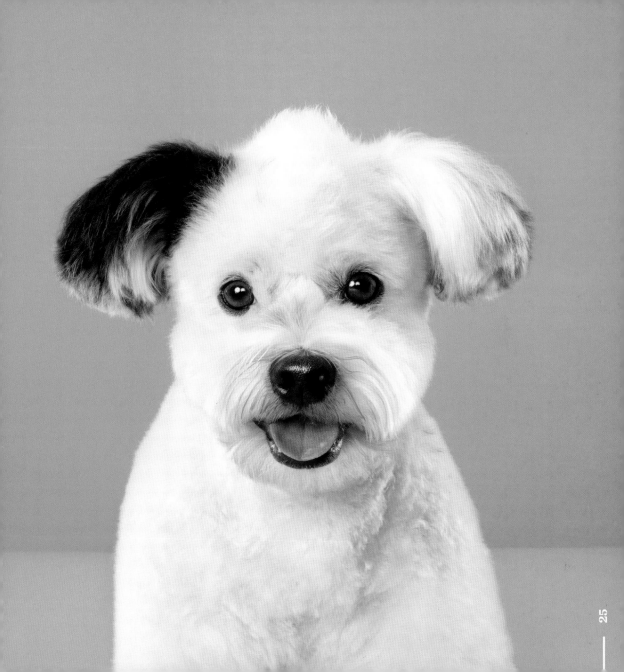

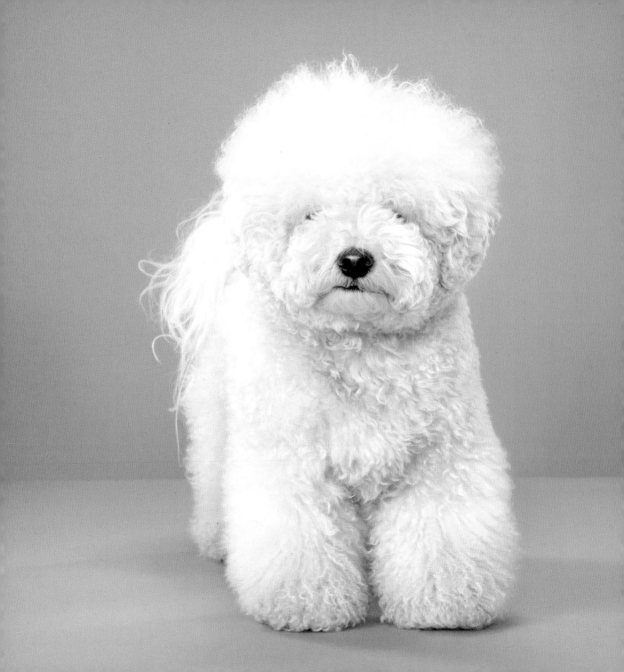

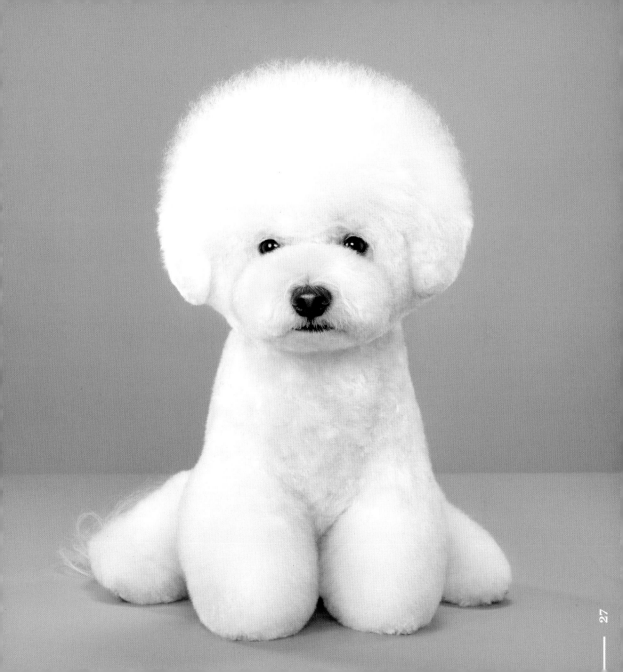

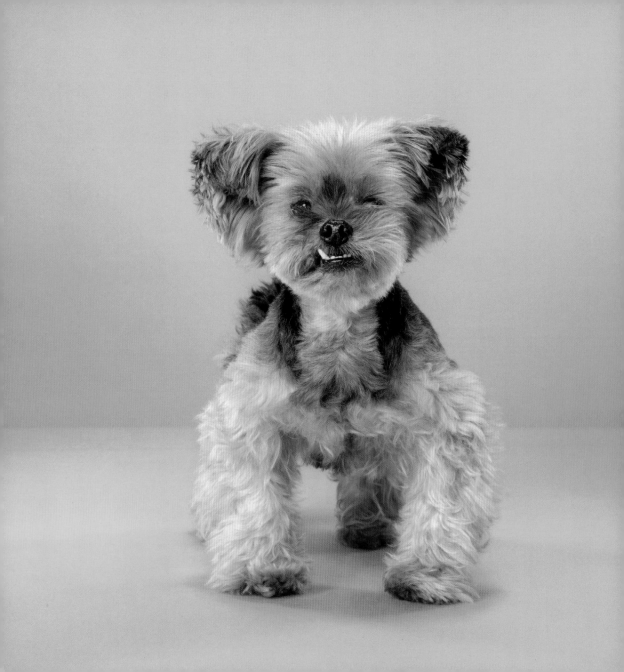

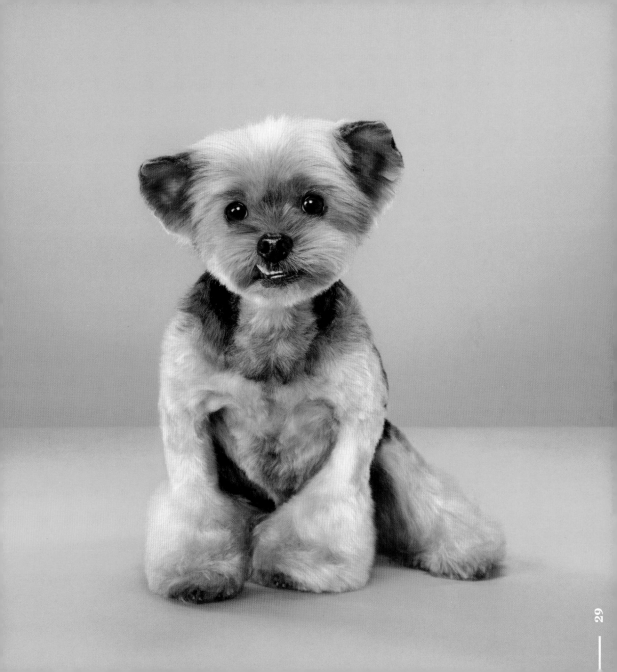

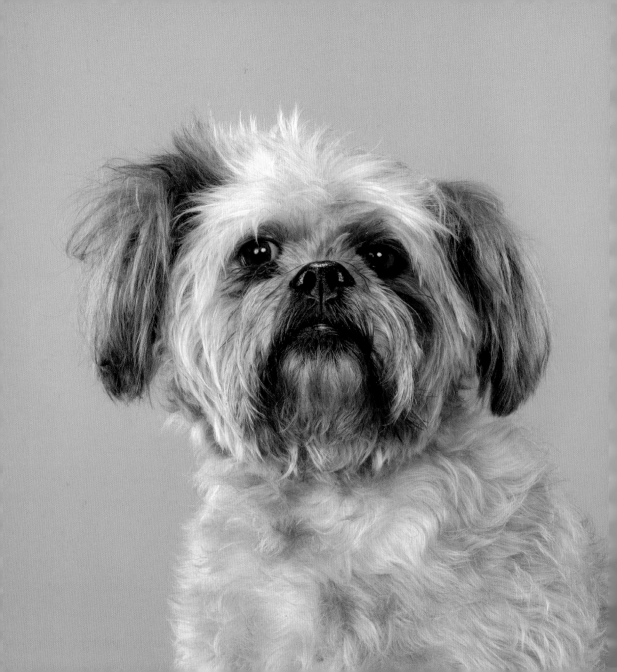

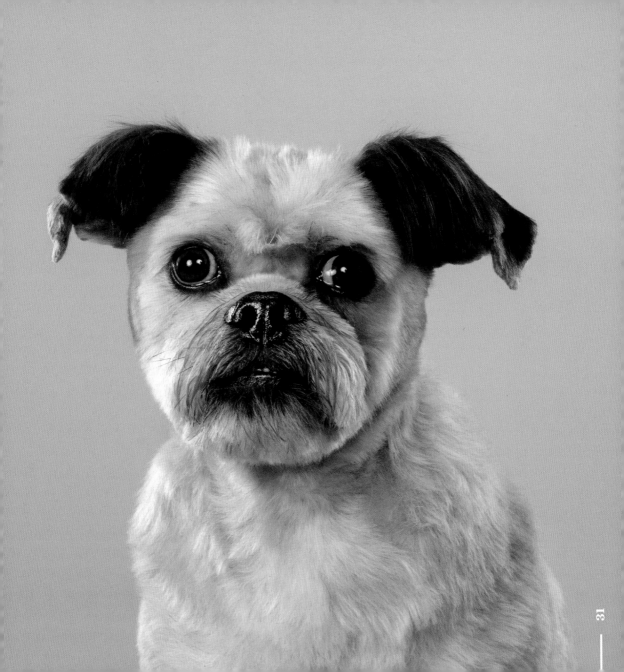

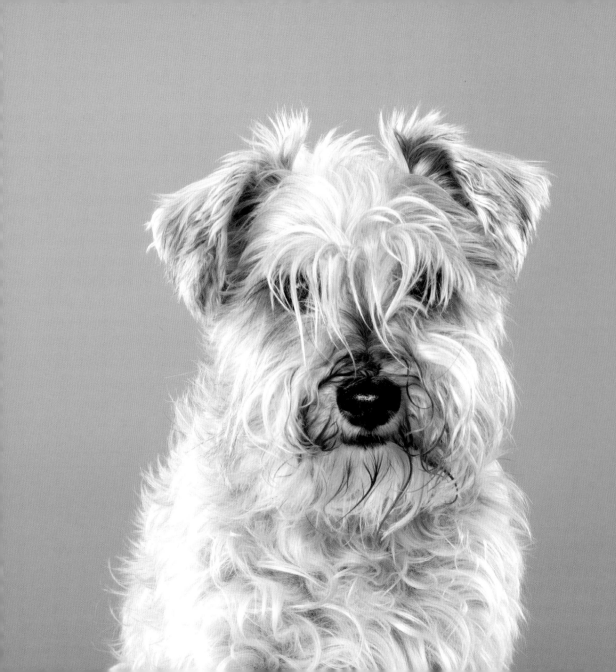

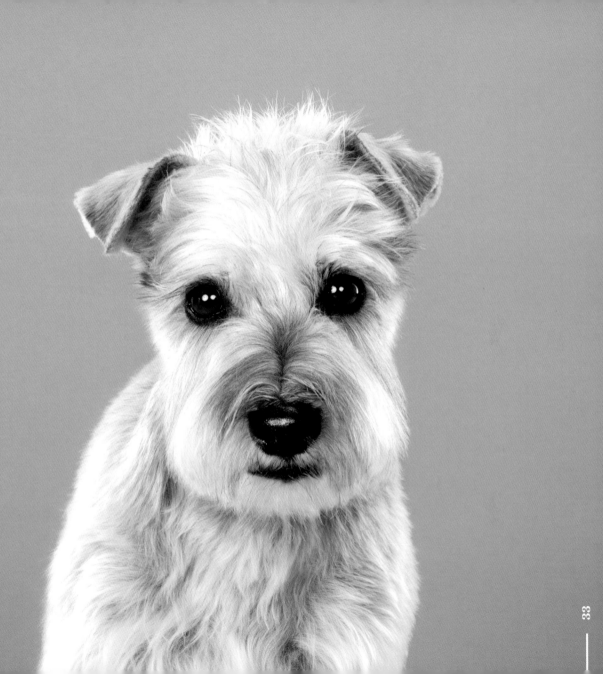

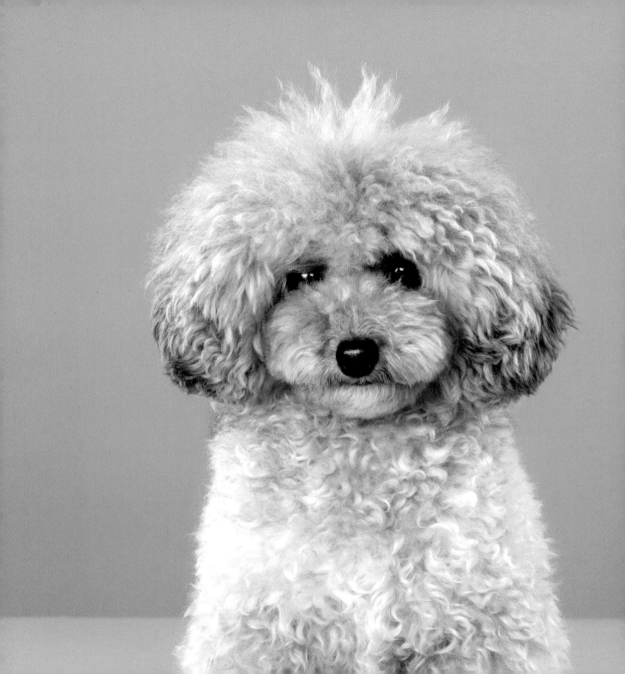

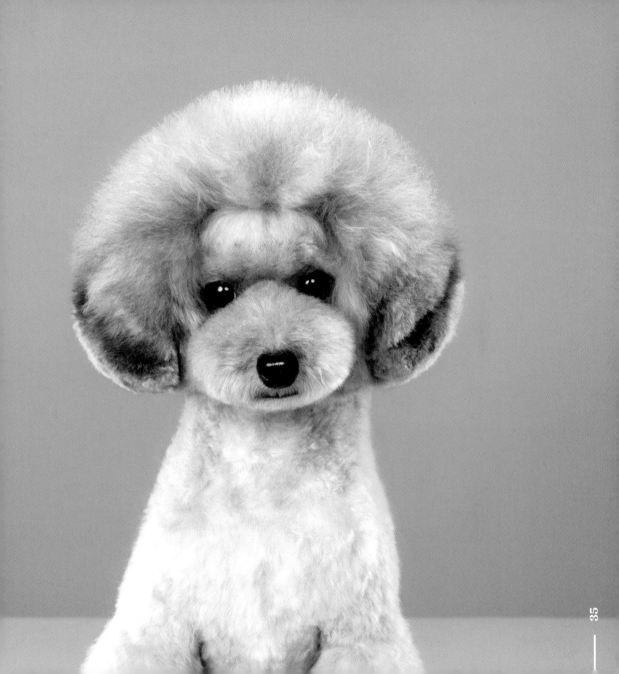

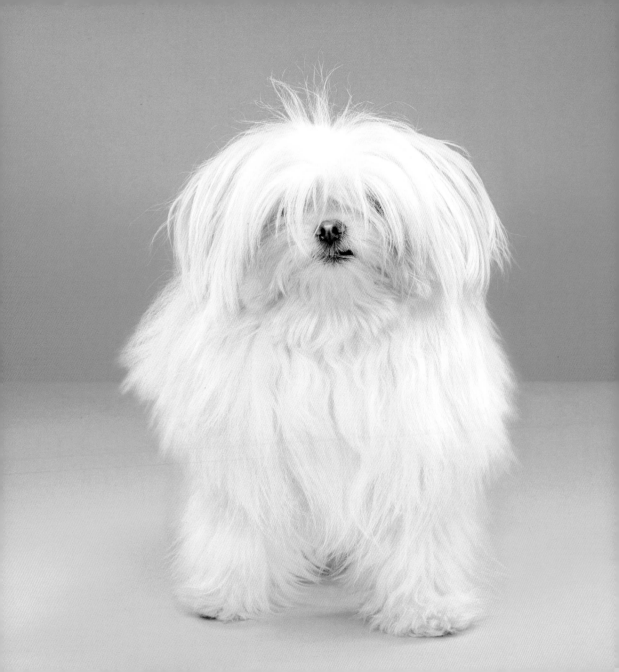

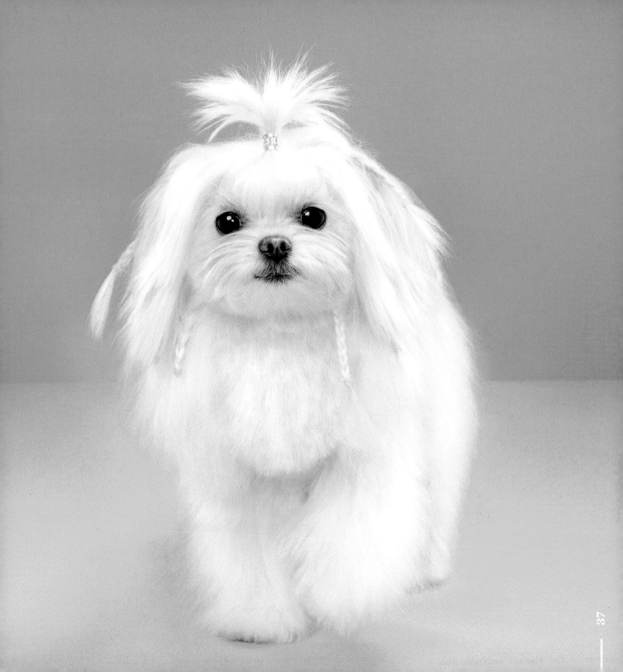

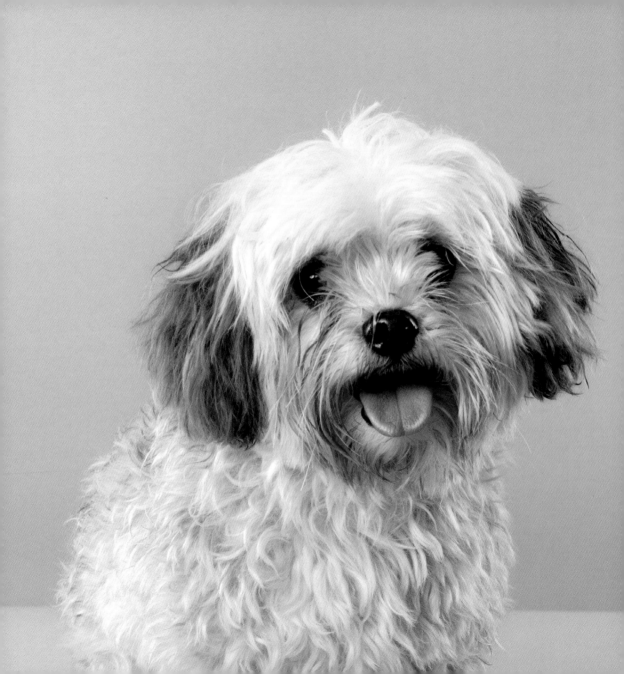

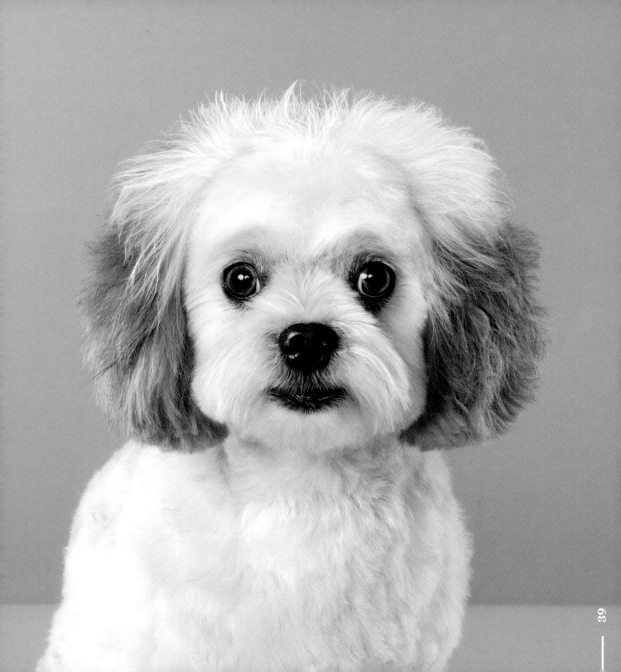

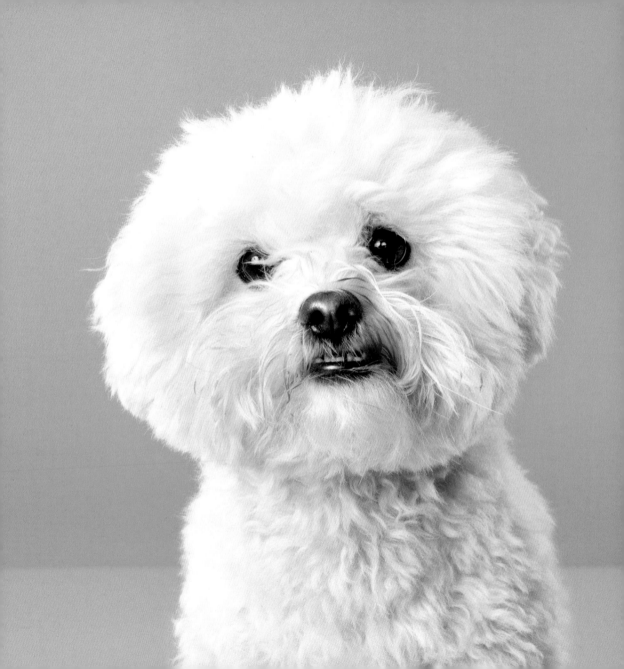

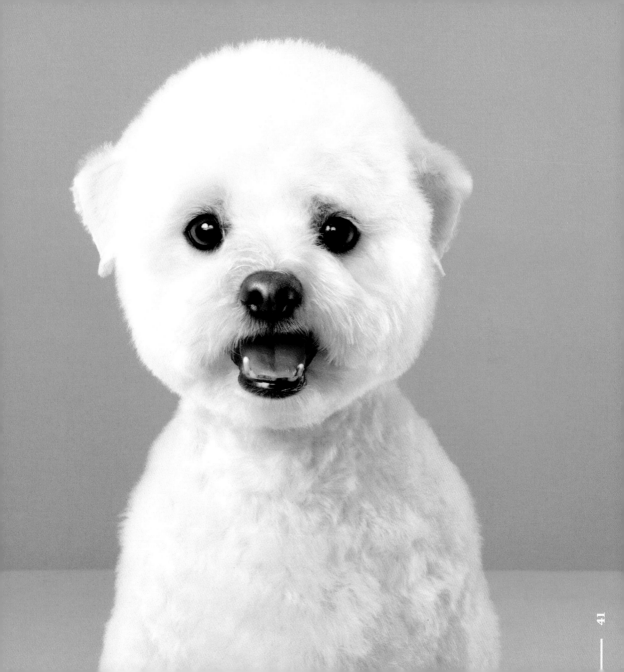

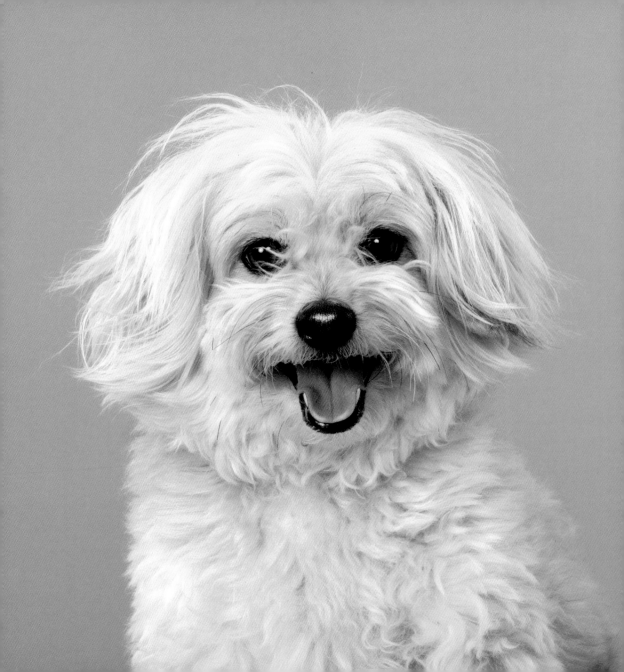

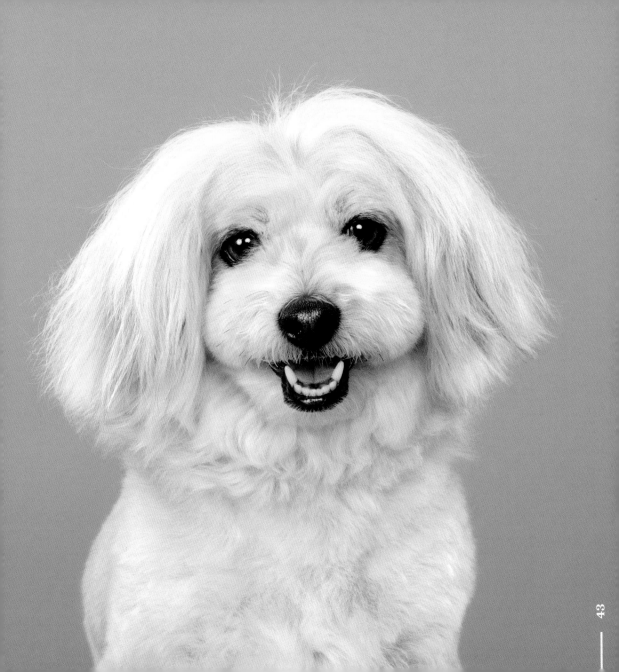

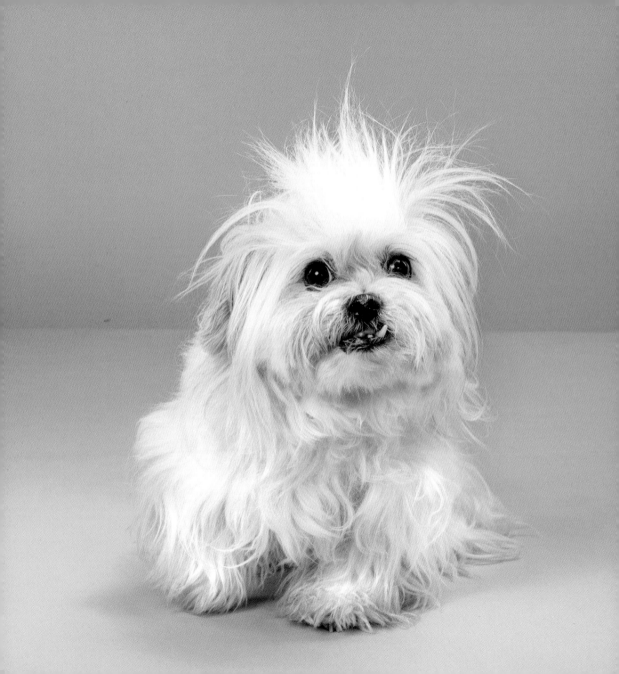

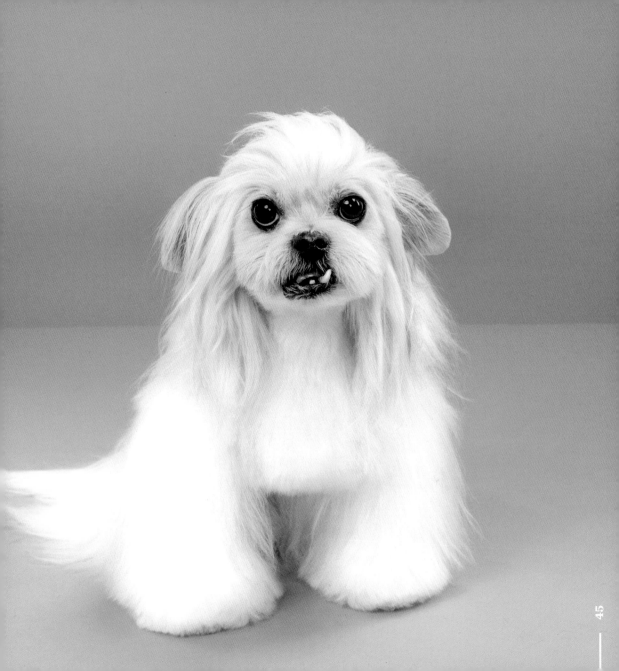

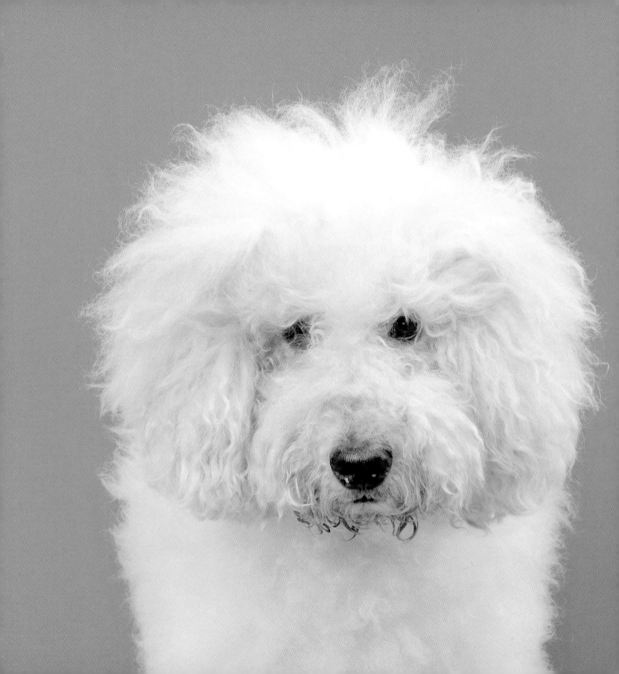

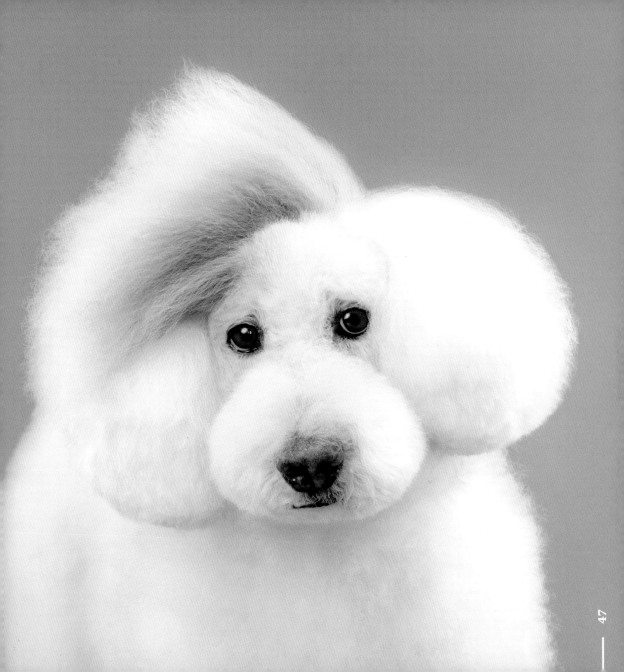

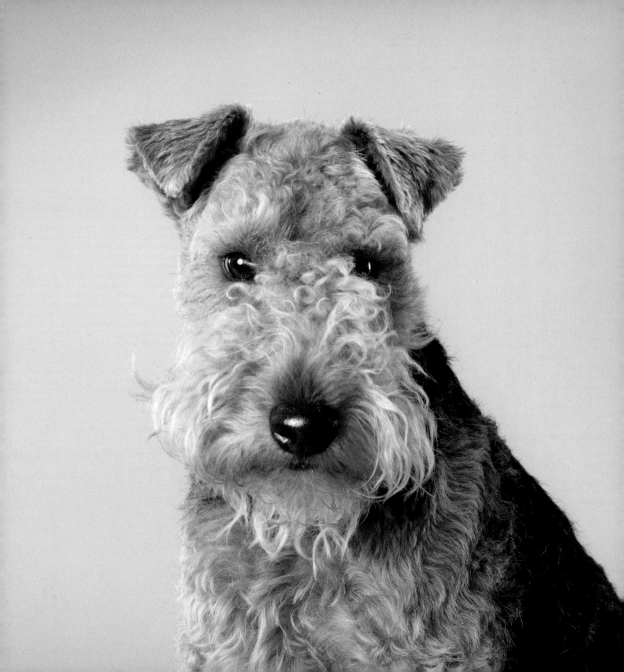

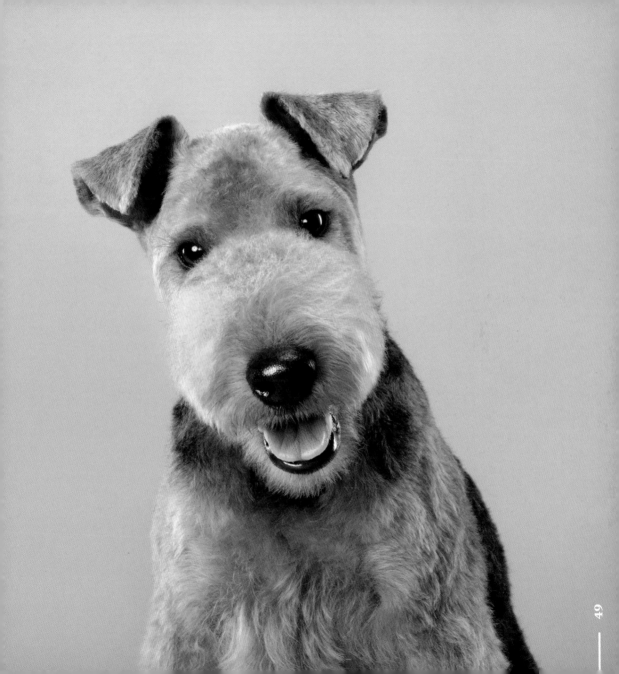

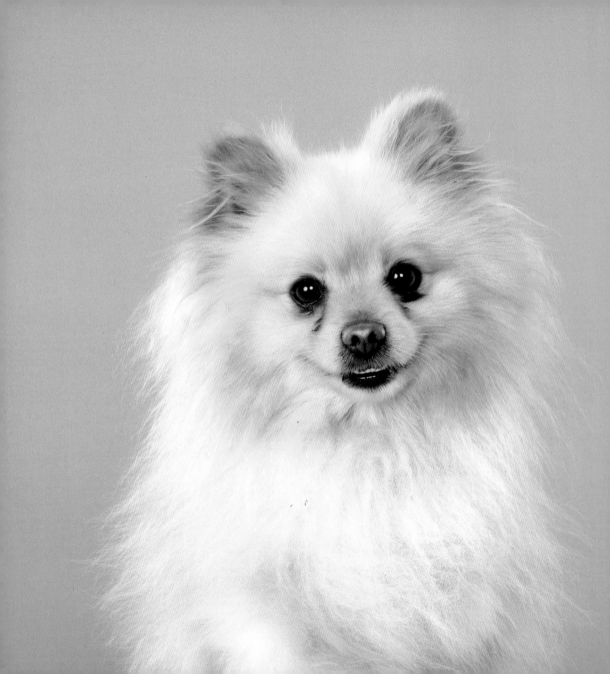

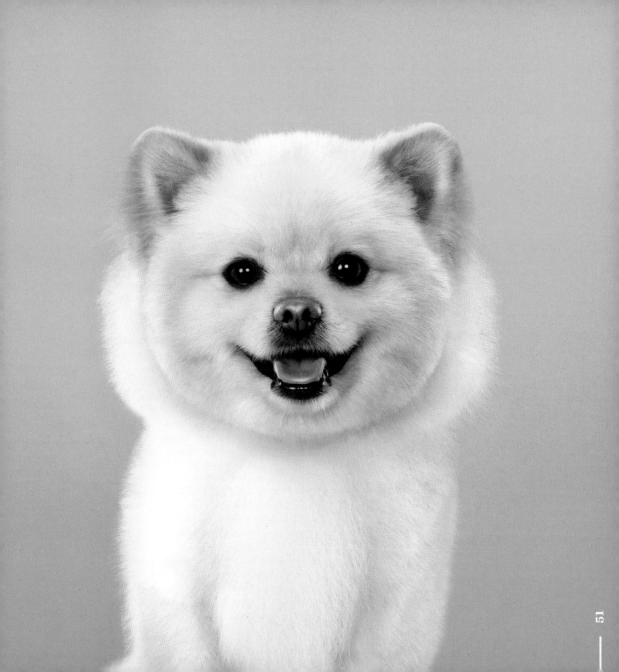

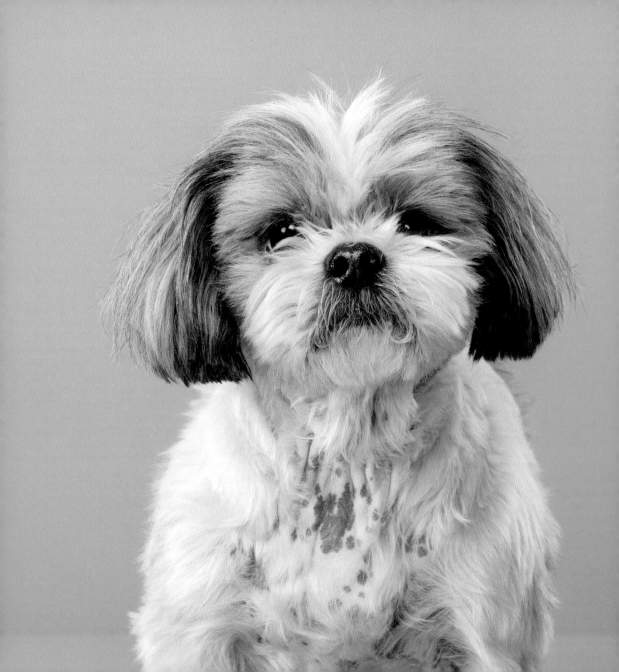

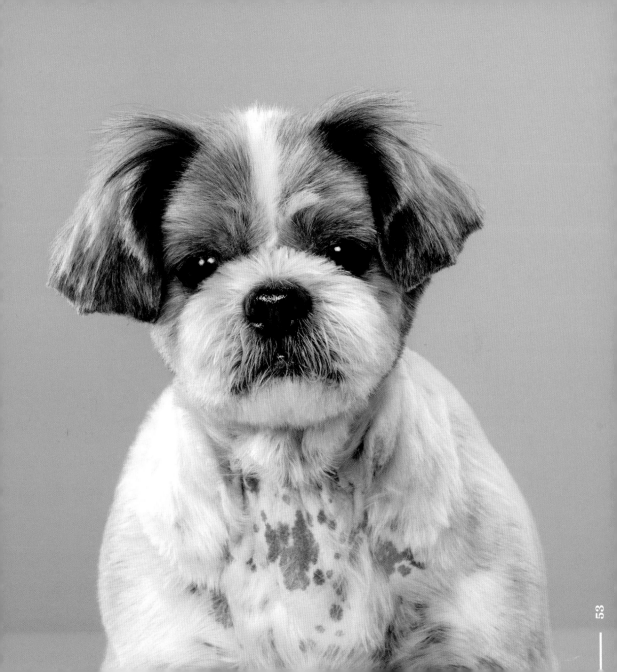

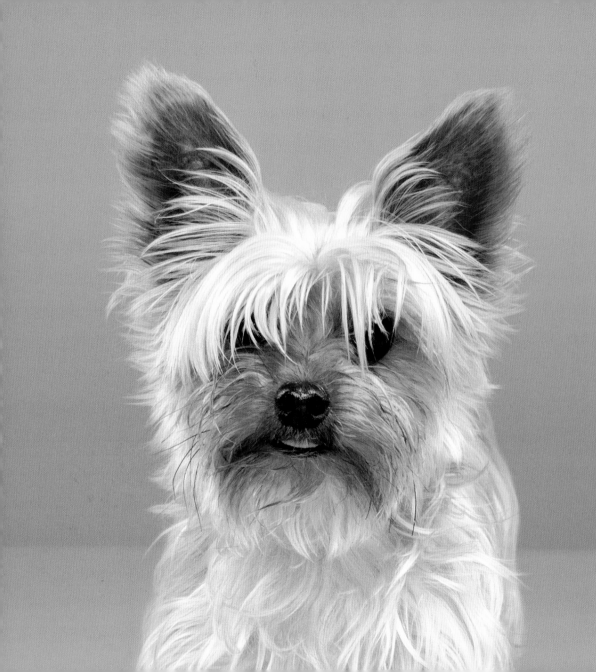

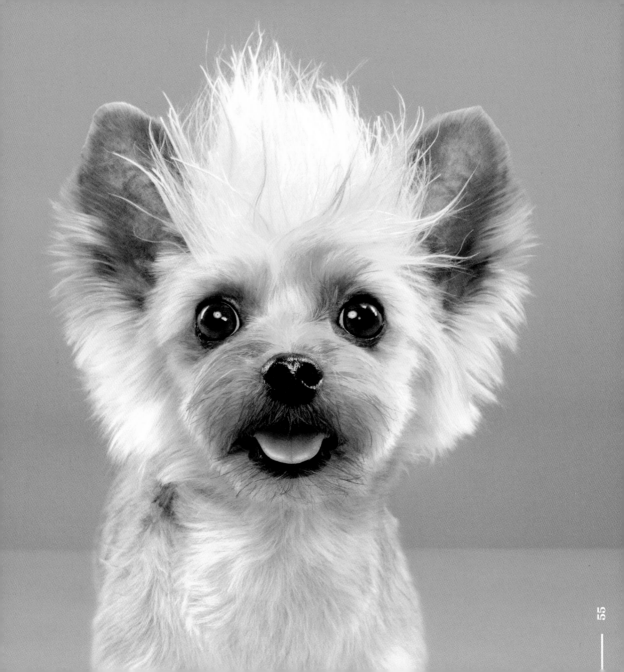

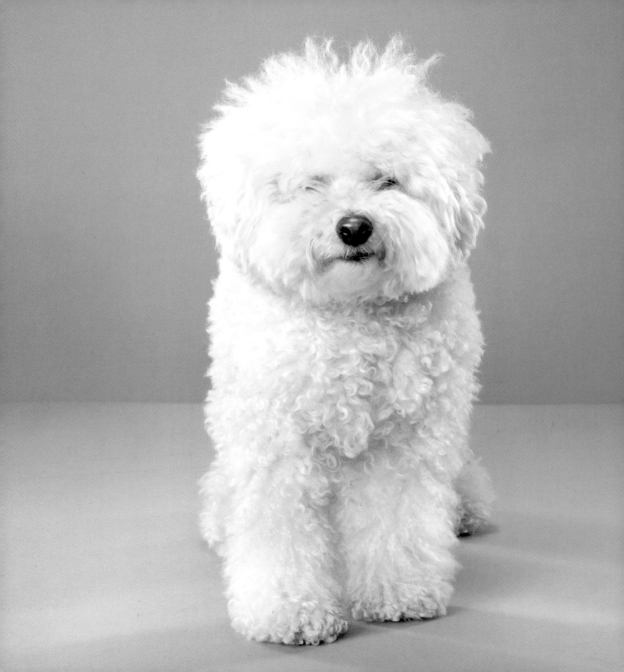

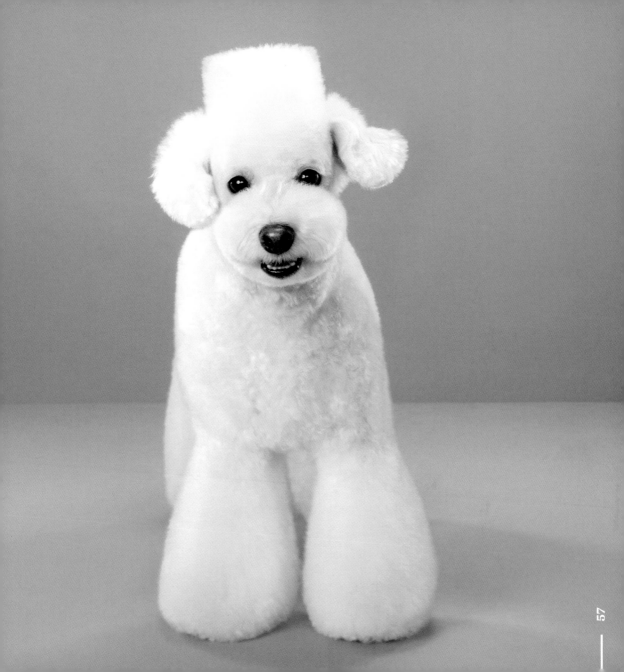

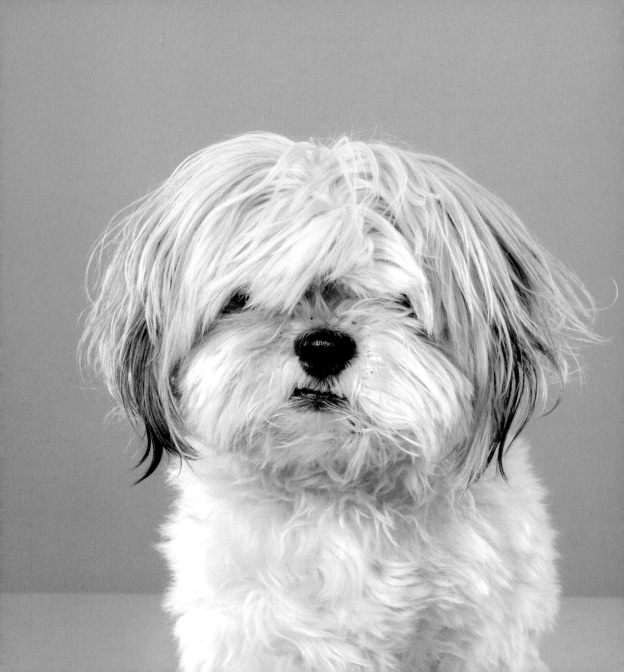

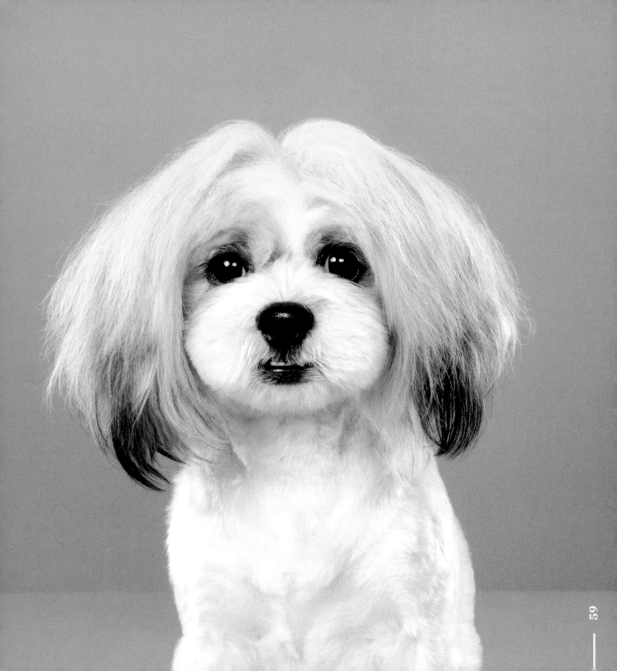

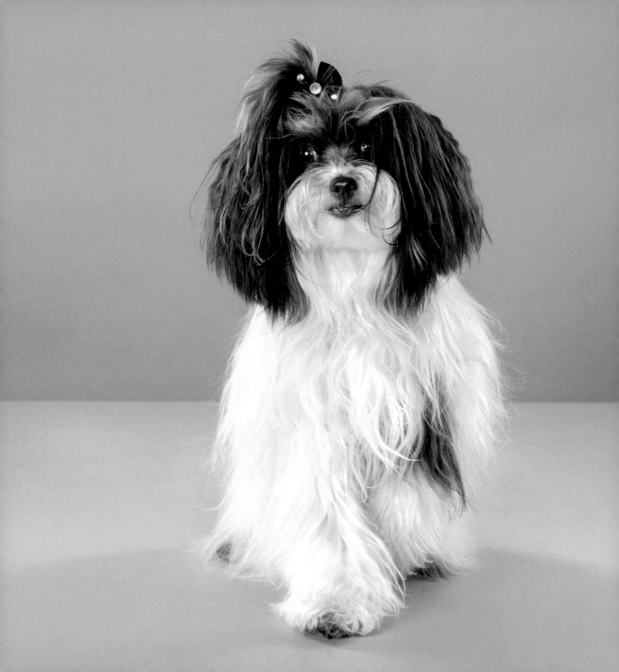

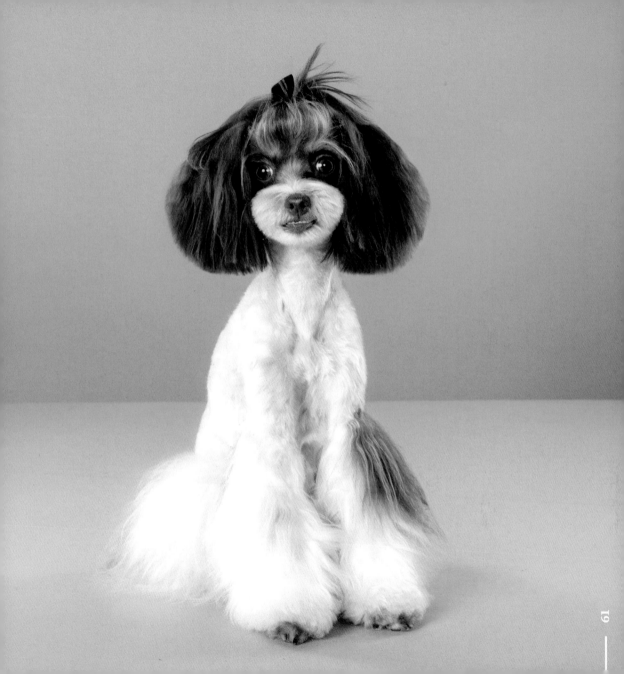

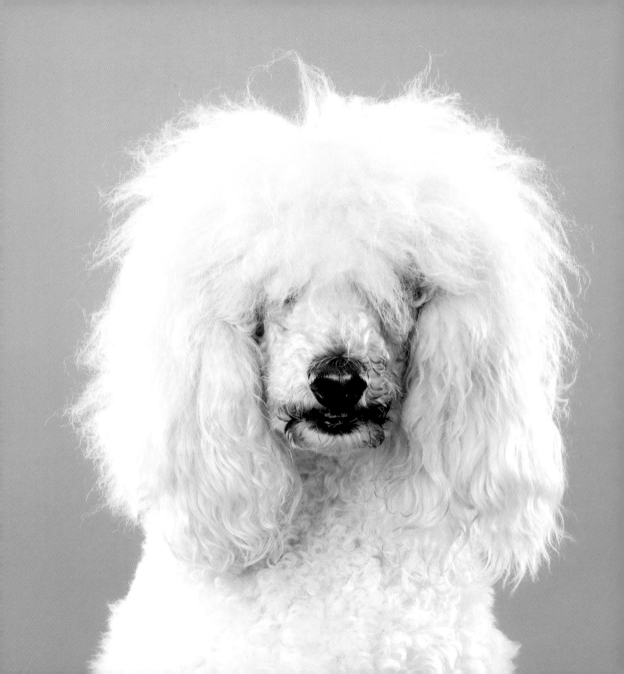

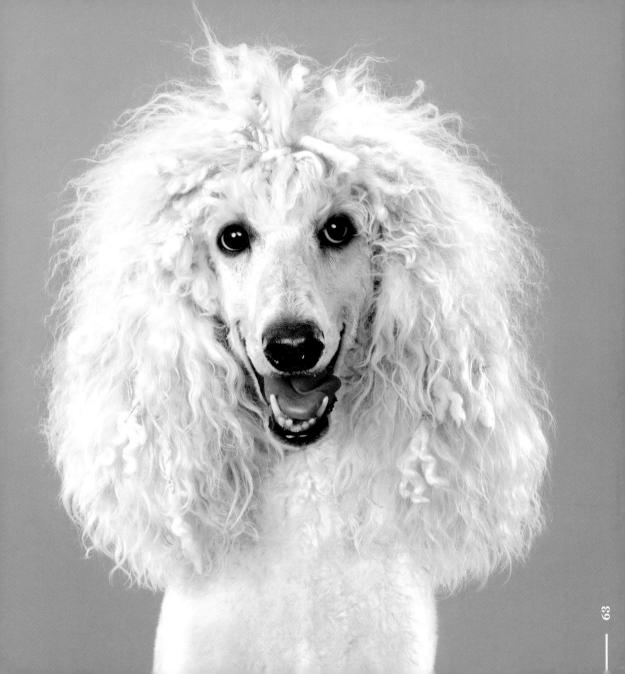

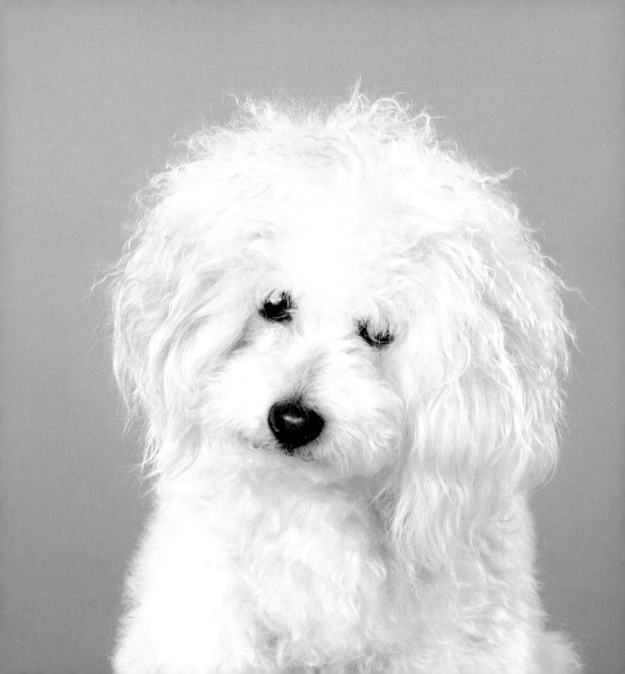

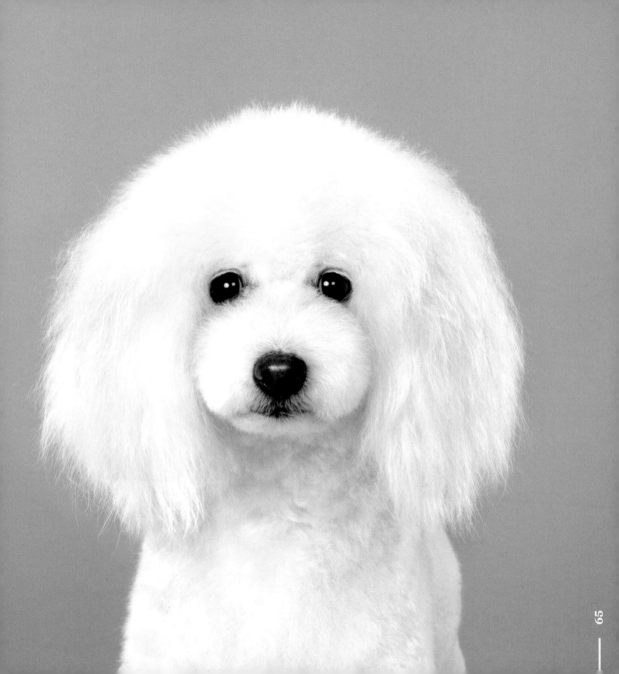

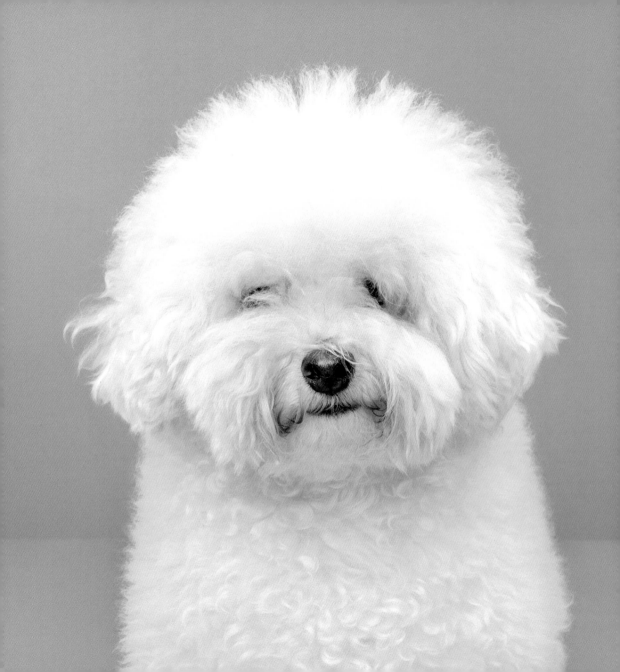

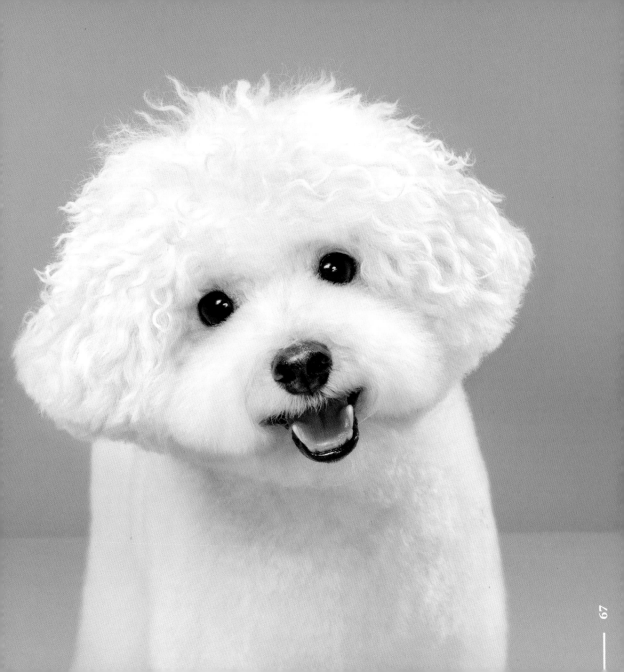

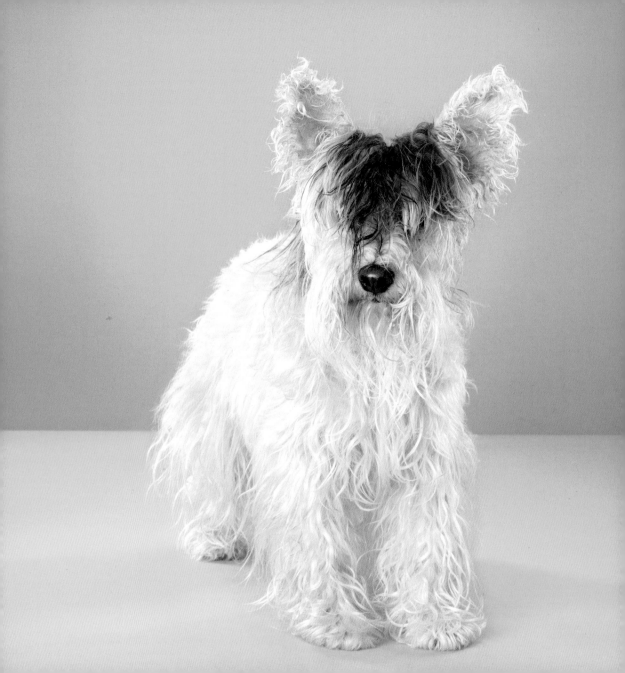

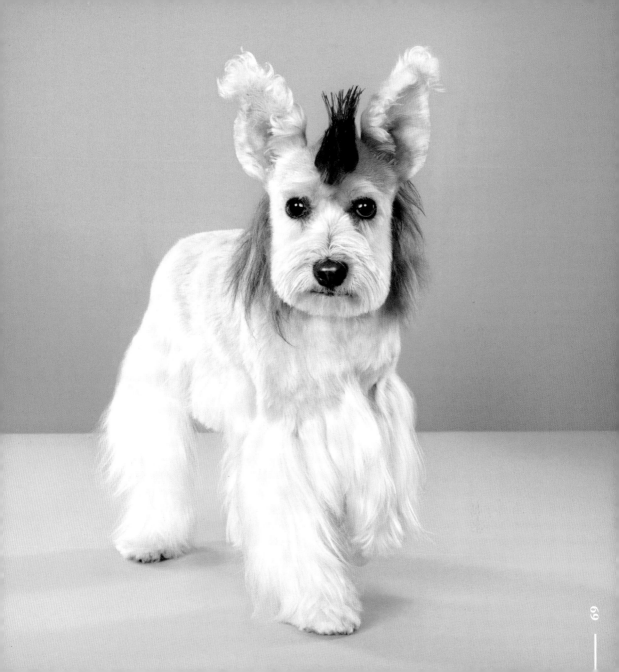

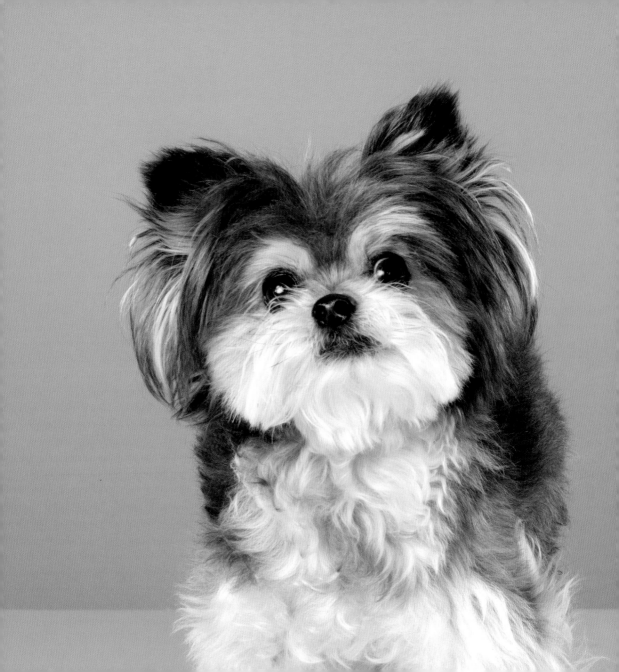

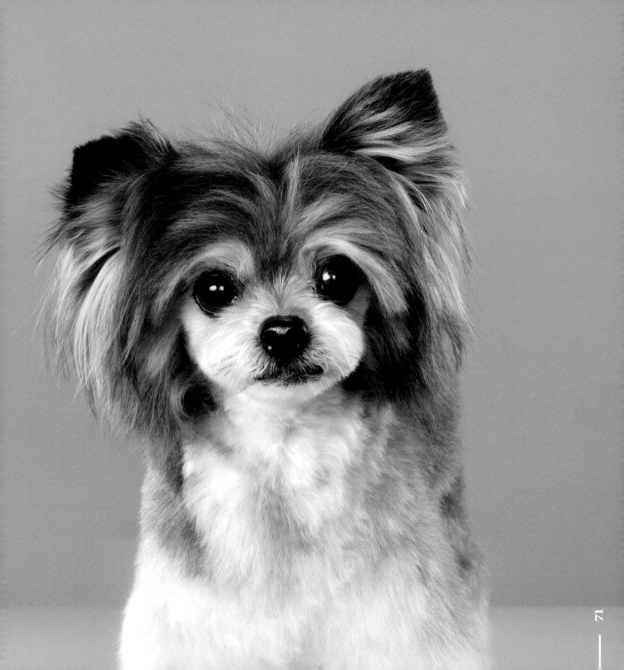

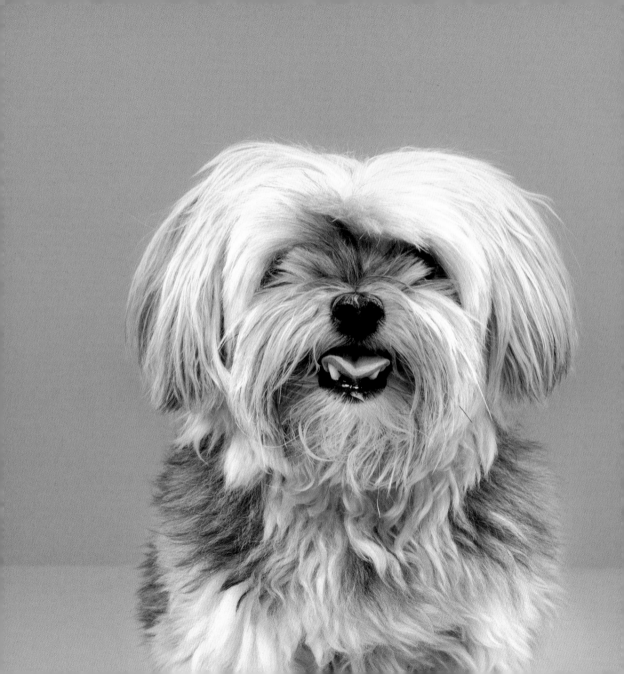

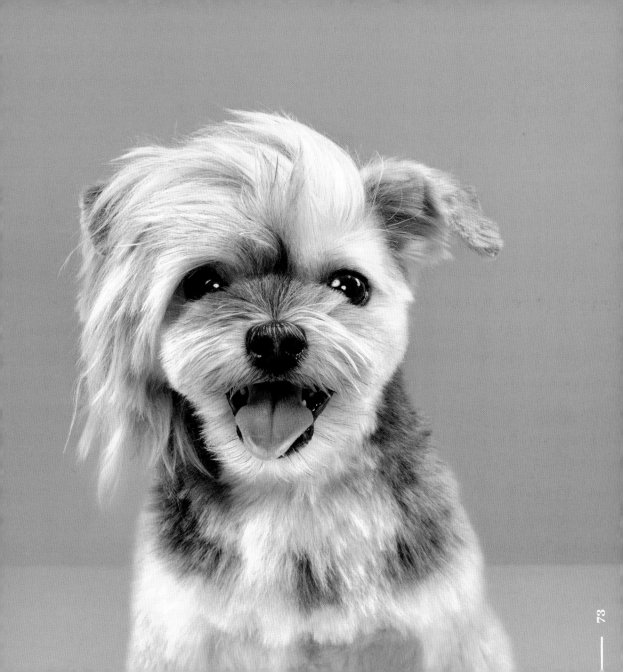

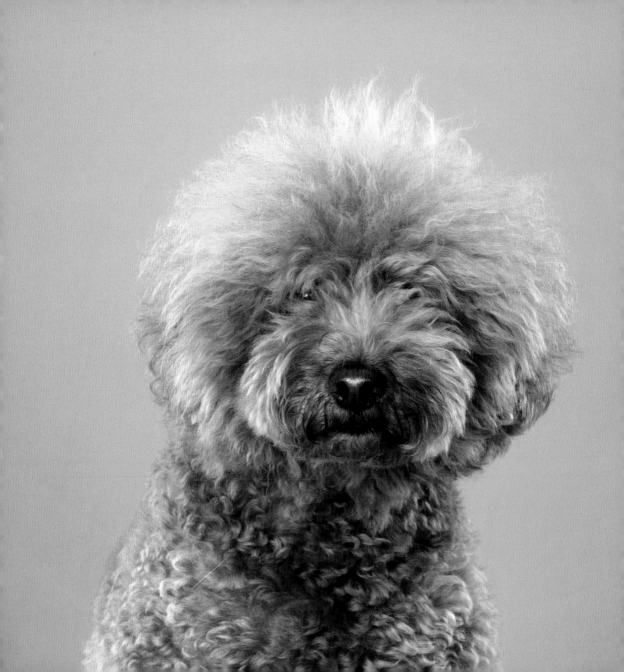

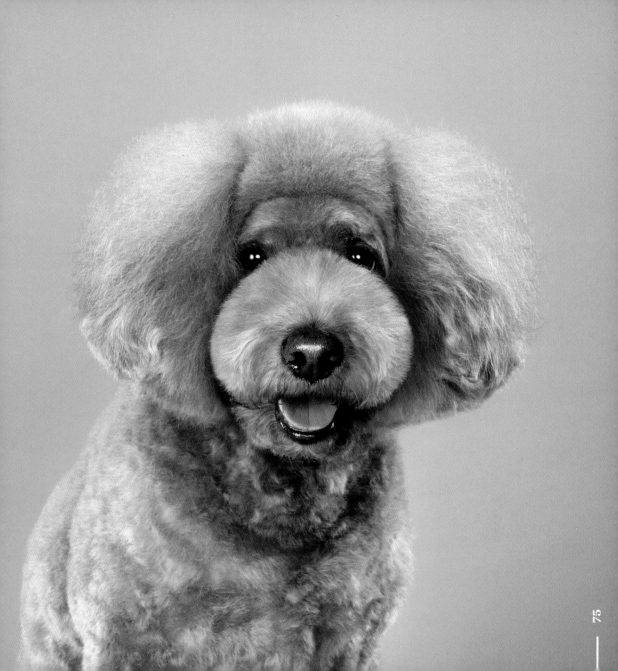

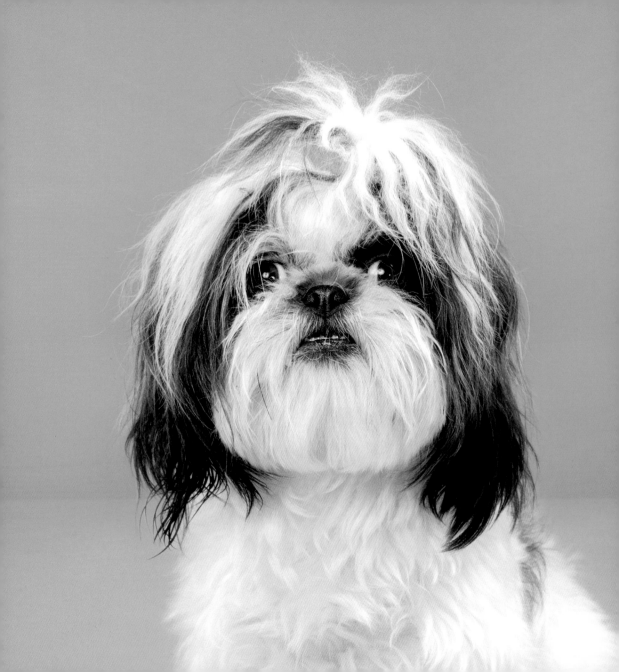

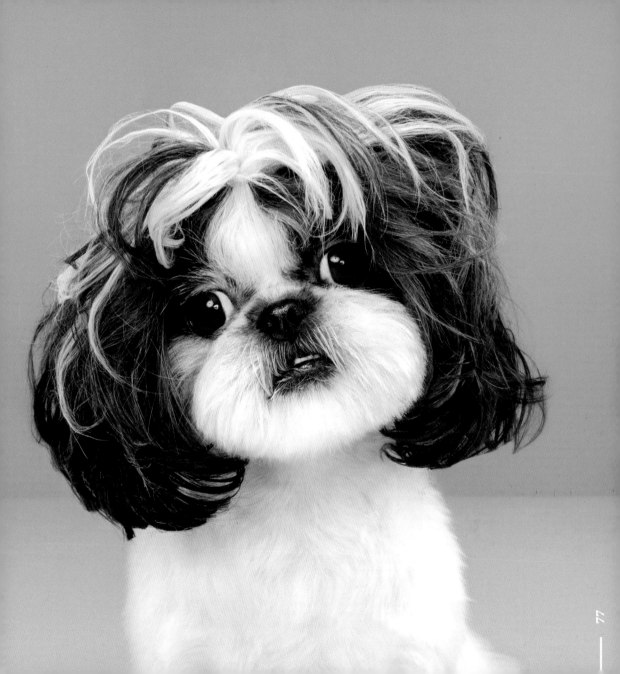

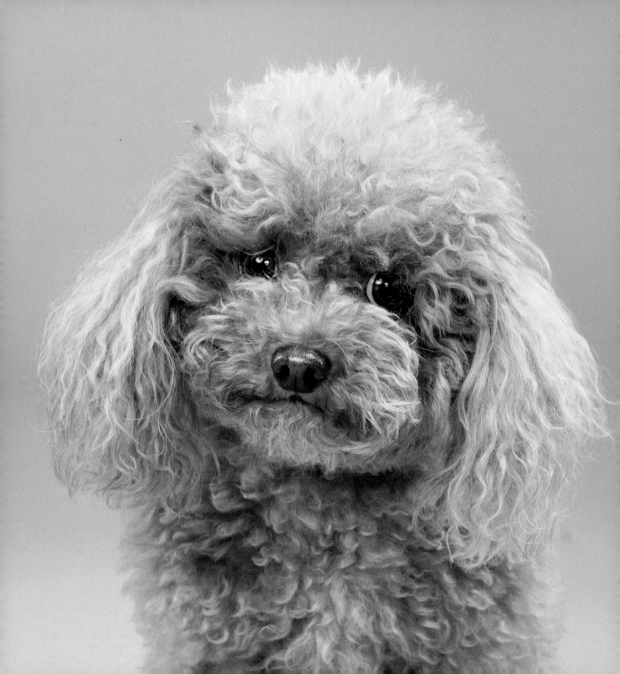

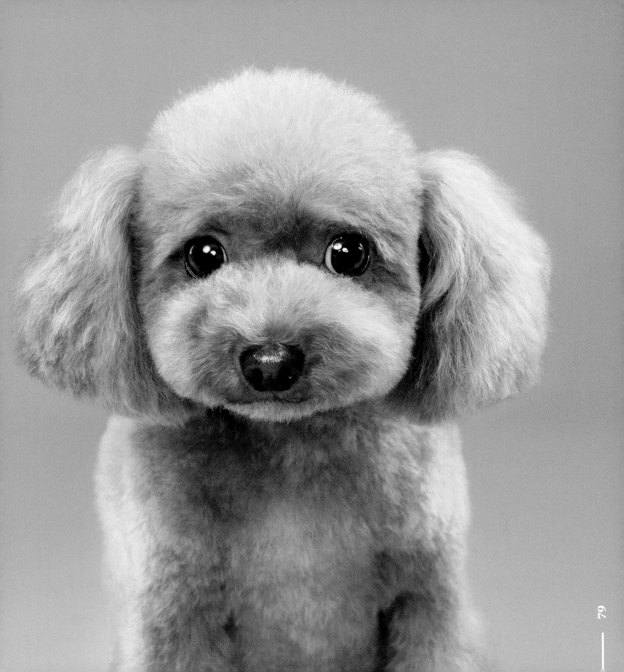

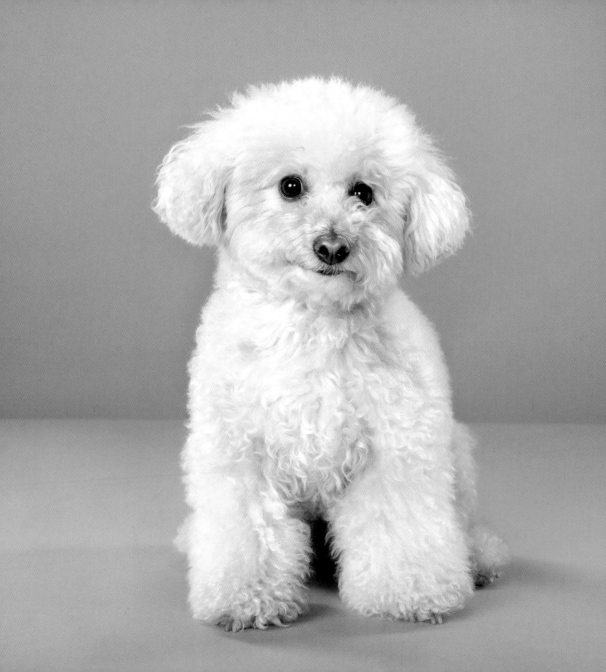

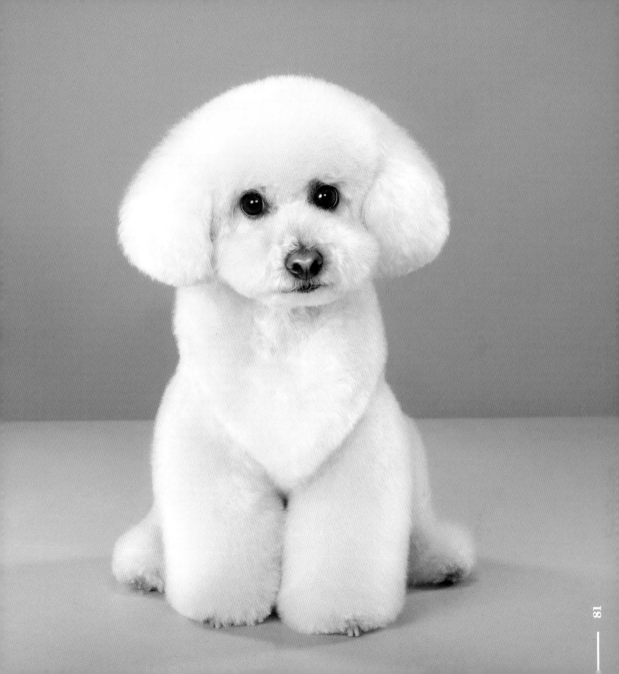

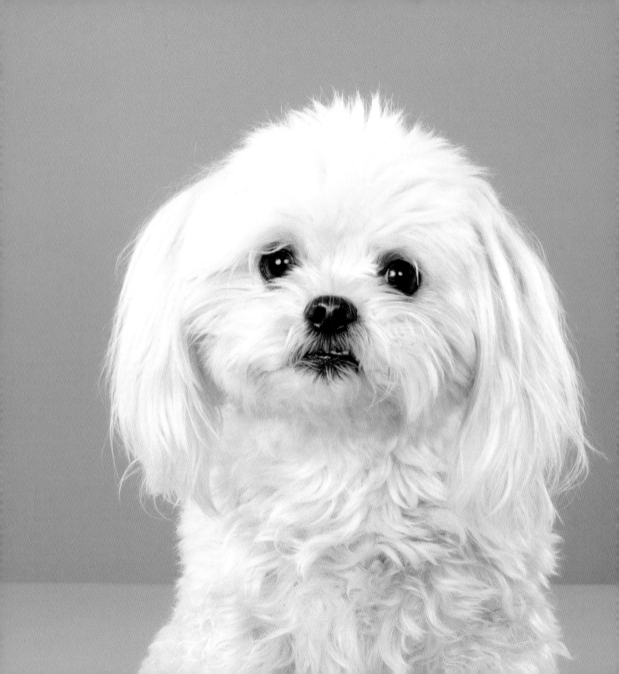

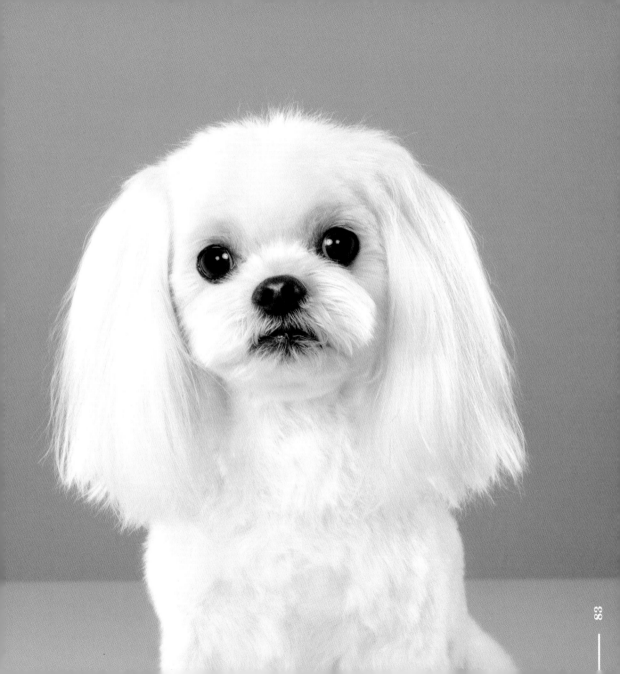

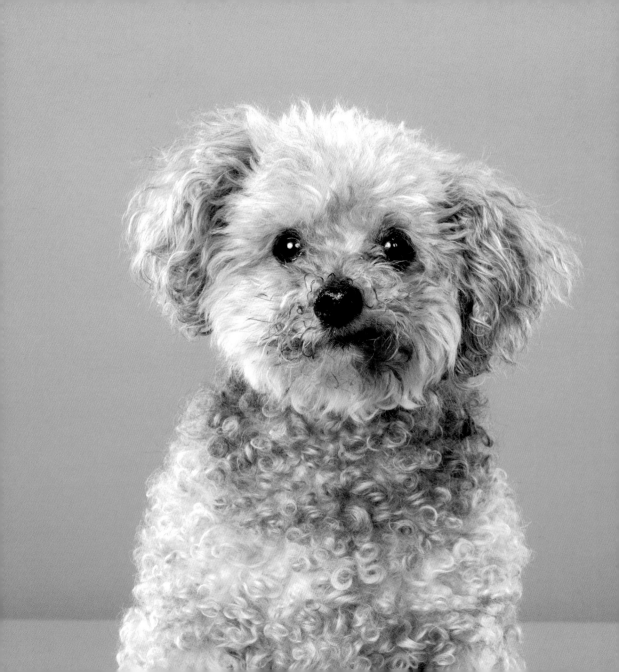

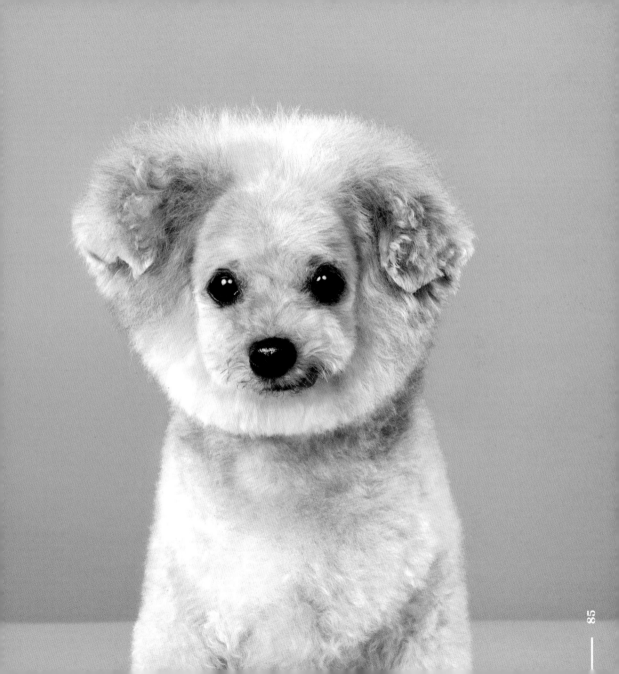

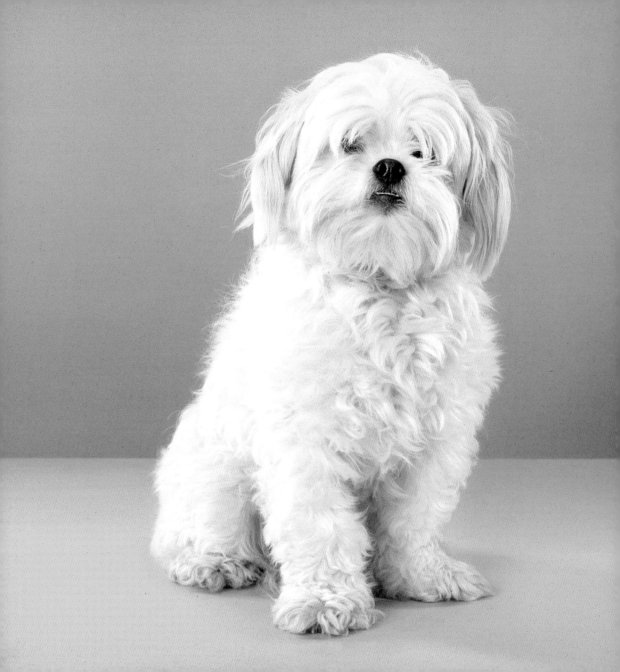

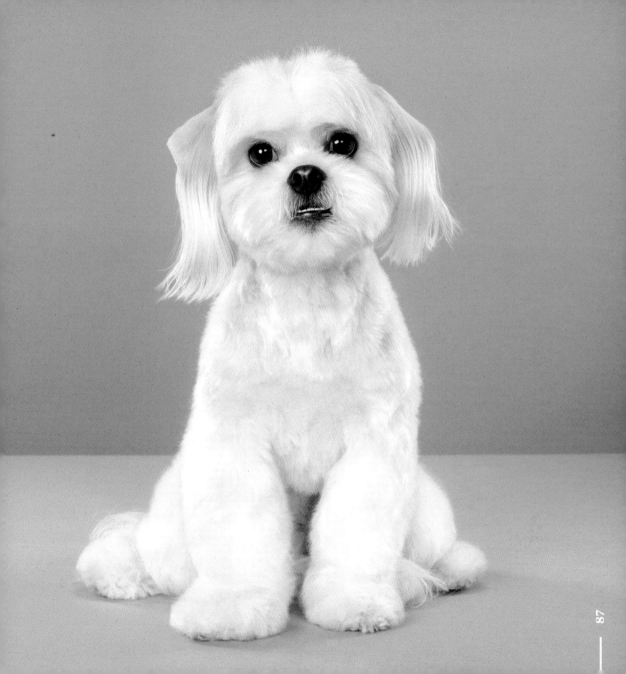

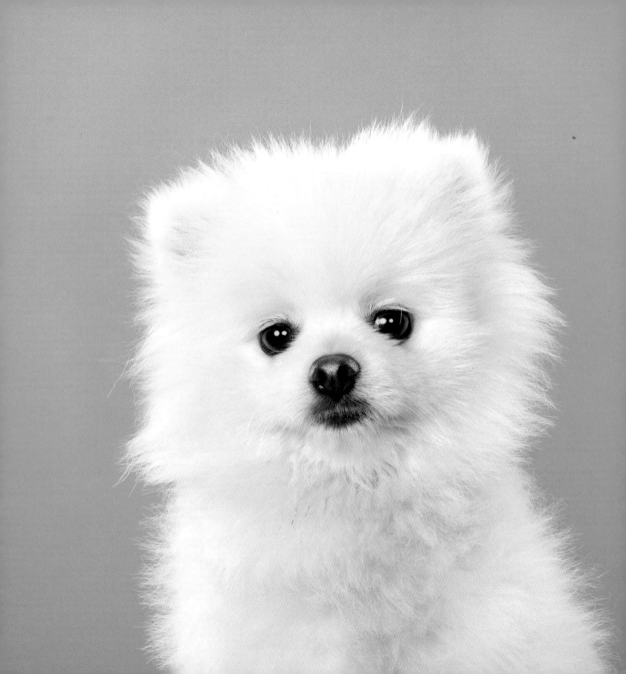

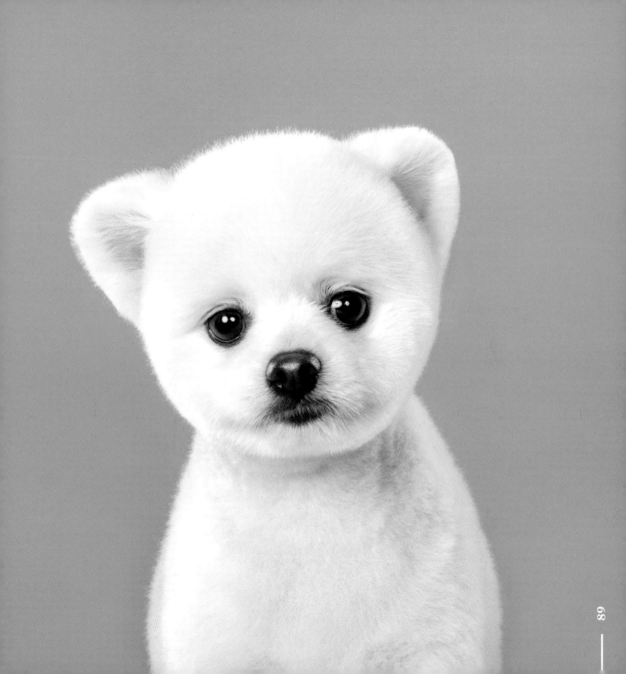

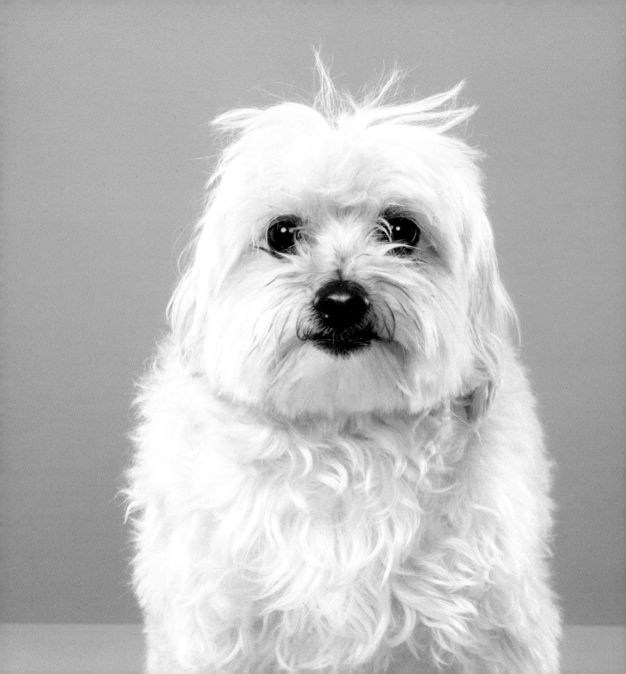

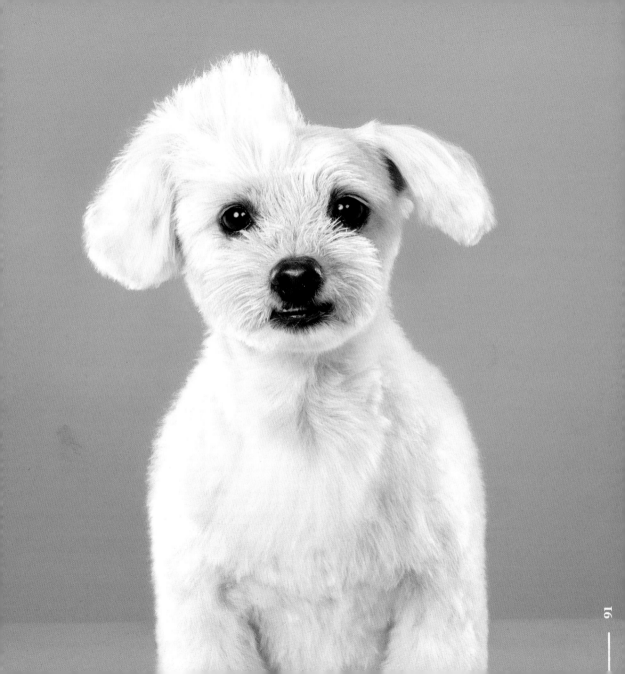

Catalog of Dogs

MESSI
Breed: Shih Tzu/Poodle
Groomer: Koko Fukaya

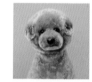
BUDDY
Breed: Miniature Poodle
Groomer: Koko Fukaya

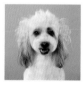
FOZZIE
Breed: Pomeranian/Yorkie
Groomer: Cameron Adkins

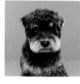
RAIDER
Breed: Miniature Schnauzer
Groomer: Koko Fukaya

FRANKIE
Breed: Lhasa Apso/Coton de Tulear
Groomer: Cameron Adkins

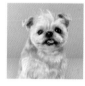
GRIFFIN NEWMAN
Breed: Brussels Griffon
Groomer: Cameron Adkins

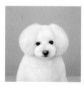
JOY
Breed: Bichon Frise/Poodle
Groomer: Koko Fukaya

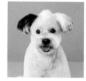
GEORGE
Breed: Lhasa Apso/Coton de Tulear
Groomer: Cindy Reyes

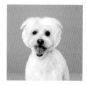
ROMEO
Breed: Maltese
Groomer: Patricia Sugihara

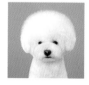
BOWIE
Breed: Bichon Frise
Groomer: Rebecca Bradford

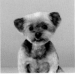

JIMMY
Breed: Yorkshire Terrier
Groomer: Cindy Reyes

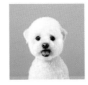

KAI
Breed: Bichon Frise
Groomer: Koko Fukaya

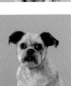

CHUCK
Breed: Brussels Griffon/
Lhasa Apso
Groomer: Donna Owens

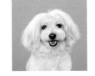

NIKKI
Breed: Pomeranian/Poodle
Groomer: Patricia Sugihara

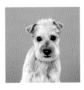

IVY
Breed: Miniature Schnauzer
Groomer: Rebecca Bradford

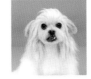

LANA
Breed: Shih Tzu/Maltese
Groomer: Koko Fukaya

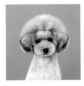

ROY
Breed: Toy Poodle
Groomer: Angie Choi

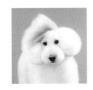

ATHENA
Breed: Standard Poodle
Groomer: Donna Owens

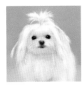

YUKI
Breed: Maltese
Groomer: Alyson Ogimachi

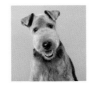

COOPER
Breed: Welsh Terrier
Groomer: Koko Fukaya

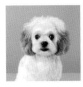

WALLY
Breed: Shih Tzu/Poodle
Groomer: Donna Owens

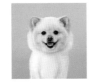

SIMBA
Breed: Pomeranian
Groomer: Donna Owens

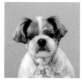

KOBE
Breed: Shih Tzu
Groomer: Patricia Sugihara

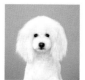

LOLO
Breed: Miniature Poodle
Groomer: Koko Fukaya

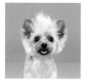

TEDDY
Breed: Yorkshire Terrier
Groomer: Donna Owens

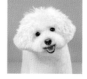

HERMAN
Breed: Bichon Frise
Groomer: Cindy Reyes

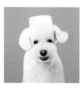

HERMAN
Breed: Bichon Frise
Groomer: Patricia Sugihara

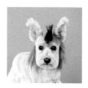

BACARDI
Breed: Miniature Schnauzer
Groomer: Donna Owens

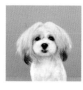

BELLA
Breed: Shih Tzu/Poodle
Groomer: Koko Fukaya

NINJA
Breed: Chihuahua/Poodle
Groomer: Patricia Sugihara

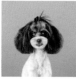

COCO
Breed: Shih Tzu
Groomer: Donna Owens

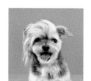

ROCCO
Breed: Yorkshire Terrier
Groomer: Patricia Sugihara

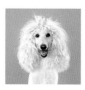

CALVIN
Breed: Standard Poodle
Groomer: Koko Fukaya

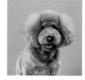

NOAH
Breed: Miniature Doodle
Groomer: Patricia Sugihara

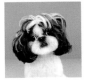
NALA
Breed: Shih Tzu
Groomer: Alyson Ogimachi

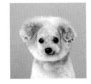
MURPHY
Breed: Toy Poodle
Groomer: Koko Fukaya & Patricia Sugihara

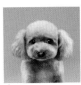
BIGGIE SMALLS
Breed: Toy Poodle
Groomer: Cameron Adkins

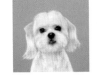
RICKY
Breed: Shih Tzu
Groomer: Donna Owens

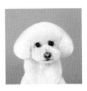
JOEY BEAR
Breed: Miniature Poodle
Groomer: Cindy Reyes

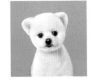
ZEUS
Breed: Pomeranian
Groomer: Rebecca Bradford

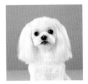
OSCAR
Breed: Maltese/Shih Tzu
Groomer: Cameron Adkins

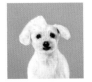
SHERLOCK
Breed: Maltese/Poodle
Groomer: Donna Owens

Thank You

To the entire Healthy Spot Grooming team that made this series possible—I truly couldn't have done this without you. Thank you Andrew Kim, Mark Boonnark, Patricia Sugihara, Donna Owens, Cindy Reyes, Cameron Adkins, Koko Fukaya, Rebecca Bradford, Angie Choi, Alyson Ogimachi, and everyone else on the grooming team.

To my incredible photo crew—Brian Faini, Ashley Poole, Brin Morris, Malia Kainoa, and Marisol Rodriguez. You're the best.

To my editor, Ann Triestman, and the amazing people at The Countryman Press for your support and guidance. Thank you for loving this book.

To all the dogs for being so patient, and to their owners for giving us the freedom to style them as creatively as we wanted.

To Lauren Kim for all your help making this book look beautiful. To Melanie Monteiro and Camille Sze for the feedback, insight, support, and laughs.

To my husband, Vincent, and son, Jasper, for being my reason for everything. I love you.

About Grace

Grace Chon is an internationally acclaimed commercial and editorial animal photographer, known for her highly expressive portraits of animals. The author of *Waggish: Dogs Smiling for Dog Reasons*, she and her work have been featured by *Good Morning America*, *The Today Show*, *The Bark Magazine*, *Huffington Post*, *BuzzFeed*, and *Oprah*.

 Grace has been photographing animals for the last 10 years, but before she stumbled upon the greatest job in the world, she was an art director in advertising. See more of Grace's work on her website and connect with her on social media. www.gracechon.com | @thegracechon. She lives in Los Angeles, California.